W9-BPN-861

• BE AN • ARTIST!

CREATIVE ART PROJECTS

Judith Falk Bergman

Troll Associates

Interior Illustrations by: Judy Moffatt

Copyright © 1992 by Troll Associates. All rights reserved.

ISBN: 0-8167-2599-3

Printed in the United States of America.

10 9 8 7 6 5 4 3

Contents

INTRODUCTION

This book provides a fun way for children to explore their creativity as they experiment with a wide variety of art media.

Be an Artist: Creative Art Projects begins with a step-by-step painting program that enables children to produce works of art they can be proud of. All subsequent art activities, including drawing, sculpting, and other crafts, draw on the things the children learn in the painting program.

Each activity in this book contains a list of materials followed by directions on how to proceed. The materials are commonly supplied by most elementary schools or can be brought from home. On occasion, an activity will call for an item that can be purchased inexpensively at a local art supply store.

Children will have oodles of fun as they become artists, creating one beautiful work after another.

Keys to a Successful Program

Preparation

For several weeks before painting begins, distribute and discuss a list of supplies that can be brought from home. The supplies include: plastic squeeze containers from dishwashing liquid or detergent to store paints; large cans for holding water; adult-size shirts for smocks; and newspapers and plastic tablecloths.

Classroom Setup and Maintenance of Supplies

An orderly and well-run classroom is essential to the success of this program. Materials should be accessible to children. This includes designating an area in which to store supplies and wet and unfinished artwork, an area that is well out of the way of classroom traffic. Arranging desks in groups of four makes it easy to share paint, water, and sponges. The classroom should also have adequate wall space for displaying the artwork. Well-trained teams of monitors can help maintain the room and care for supplies. With an increased respect for materials and equipment, children will take pride in their work.

Basic Steps for Painting

STEP I:
Selection of Monitors, Demonstration, and One-Color Experiment

SUPPLIES

- Tempera, one color
- Paintbrushes
- Newsprint
- Sponges
- Water
- Newspaper or other protective table or desk covering

PROCEDURE

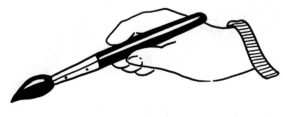

1. Select one or two monitors each to distribute and clean up water, brushes, newsprint, paint, sponges, and newspaper or other covering. Discuss responsibilities for proper use and storage of equipment and supplies. For instance, brushes should be stored with bristles up, to prevent them from drying in a crooked position.

incorrect

correct

2. Tape a sheet of newsprint to the chalkboard, then place a tin of water, one color of paint, a sponge, and a brush on your desk.
3. Instruct children on the proper way to hold the brush. For maximum control, the brush should be held like a pencil, at the bottom near the bristles, not at the top.

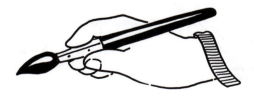

incorrect correct

4. Demonstrate the use of the brush for children by dipping it into the water tin and then wiping it up and down on the sponge. Explain that you wipe the brush to remove extra water so that the paint will not run. Next place the brush in the paint and pull it slowly across the top edge of the container. Tell the children that removing excess paint from the brush in this way will prevent dripping. Put the brush back in the water tin.

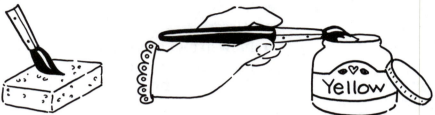

Then call on a volunteer to come to the board and paint a thick line on the newsprint. Check to be sure that the child goes through the entire routine of brush cleaning, sponge wiping, and paint dipping. After the volunteer completes the line, ask the class what part of the brush was used to make the line. The class will observe that the fat, or wide, part of the brush was used. Repeat this procedure for a thin line. The class will learn that the top edge or side of the brush was used to paint a thin line. Continue by demonstrating how to make shapes by outlining and by using the inside-to-outside method. Discuss the use of patterns, which are the repetition of lines and shapes. In other words, encourage discovery of "what the brush can do."

outlining shapes

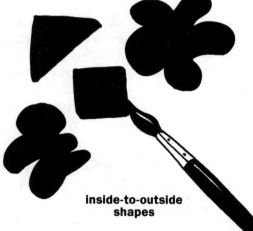

inside-to-outside shapes

5. Have monitors distribute materials. Encourage children to experiment with lines and shapes in one color.

STEP II:
Two-Color Experiment

SUPPLIES
- Tempera, two contrasting colors
- Paintbrushes
- Newsprint
- Sponges

PROCEDURE

1. Explain the two-color experiment in terms of technique. Emphasize the importance of rinsing one color off the brush before dipping it into the next color. Also, remind children to let one color dry before painting next to it with another, so the colors won't run together.
2. Explain the two-color experiment in terms of design. Discuss contrast and color dominance, or one color being a "leader" over another. Tell children to cover the whole paper, leaving no unpainted areas.
3. Distribute materials and paint, paint, paint!

STEP III:
Three-Color Experiment

SUPPLIES
- Tempera, three colors
- Paintbrushes
- Newsprint
- Sponges

PROCEDURE
1. Discuss the three-color experiment in terms of technique. Emphasize brush cleaning and drying time.
2. Discuss the three-color experiment in terms of design. Stress the concept of variety with sizes, lines, and shapes.
3. Distribute materials and ask children to create a beautiful and interesting three-color design.

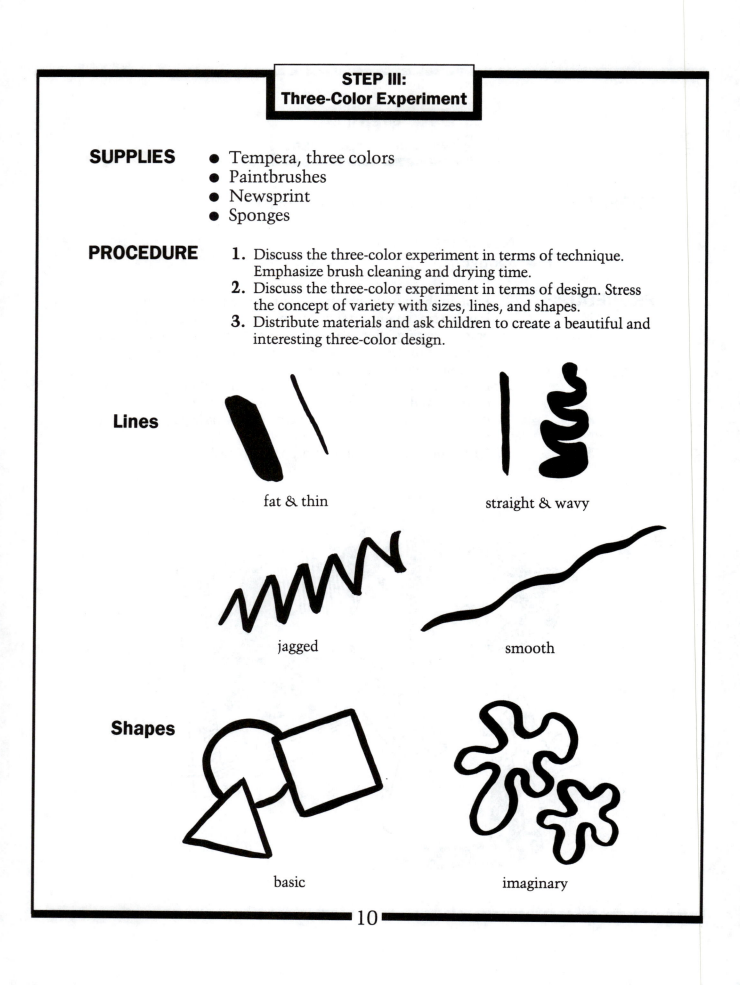

Lines

fat & thin

straight & wavy

jagged

smooth

Shapes

basic

imaginary

STEP IV:
Four-Color Experiment

SUPPLIES
- Tempera, four colors
- Paintbrushes
- Newsprint
- Sponges

PROCEDURE
1. Discuss the four-color experiment in terms of technique.
2. Discuss the four-color experiment in terms of design concepts relating to color, shape, size, pattern, and contrast. Introduce the concept of unity, which is holding together the entire design using repetition of design elements.
3. Distribute materials and encourage children to have fun as they make unusual designs.

STEP V:
Designing with Mixed Colors

SUPPLIES
- Tempera, two primary colors plus white
- Paintbrushes
- Newsprint
- Sponges

PROCEDURE
1. Demonstrate mixing two primary colors to achieve a secondary color. For instance, red + yellow = orange. Add white to any or all three colors. Experiment to achieve different variations of light and dark.
2. Distribute materials and create a beautiful and exciting design. Reemphasize concepts of line, shape, size, pattern, and unity.

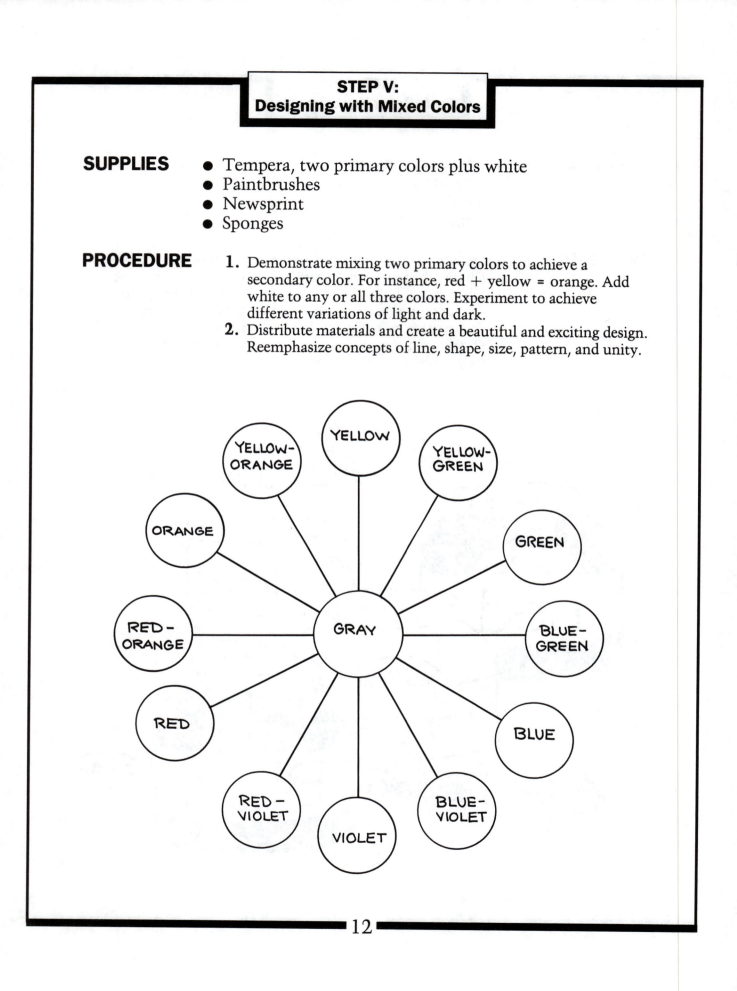

STEP VI:
Designing with a Full Range of Mixed Colors

SUPPLIES
- Tempera, three primary colors plus black and white
- Paintbrushes
- Newsprint
- Sponge

PROCEDURE

1. Mix two primary colors to achieve a third color. Use two other primary combinations to achieve a third color. Mix black and white with available colors. At this point, the color wheel would make an excellent visual aid.

2. Distribute materials and encourage designing with a full range of color. Stress all color contrasts: dark against light, bright against dull, warm against cool, and plain against patterned.

At this point you have the option of continuing with the painting steps. You should base your decision on the age and attention span of the class. If you decide to continue tempera painting, consider Steps VII–XIII. In Step VII, children paint a design using a full range of color, including green, orange, and violet. Evaluate and discuss recognizable forms in the designs. Have children clarify forms by painting in details. Steps VIII–X, for older children, deal with drawing from the posed figure. In Step VIII, select a child to pose in an action position for the class. Instruct children to draw this pose, emphasizing broad mass rather than detail. Stress directional body lines, such as hip and shoulder angles. Children draw with crayon, chalk, pastels, charcoal, or thinned tempera on large newsprint.

In Steps IX and X, repeat Step VIII, but use two, three, or more figure poses. Make sure figures overlap. Facial and clothing details may be added with a second color or darker line. Steps XI–XIII are related to painting a topic. In Step XI, choose a topic to which any child can relate, such as "My Birthday Party," "Fun at Recess," or "My Neighborhood." In Step XII, choose an imaginative topic, such as "Life Under the Sea," "My Trip to Mars," or "If I Could Fly." In Step XIII, choose a topic that reflects a mood. Discuss the use of color, line, and shape to express feelings or moods. Have children use white chalk or thinned paint to block in groups of figures, which should be drawn large so that empty background space does not become a problem.

You now have an army of experienced painters to assist you with other art-related projects. These projects may include painting scenery and costumes for a class play, illustrating social studies or science lessons, or painting posters or bulletin boards for schoolwide projects. The possibilities are endless!

The following painting activities are recommended for further experimentation with the medium.

SUPPLIES

- Tempera
- Dry or damp sponges of various sizes and shapes
- Drawing paper

PROCEDURE

1. Use a piece of sponge as a brush by dipping it in tempera.
2. Make a design on the drawing paper by experimenting with different sponge techniques such as smearing, wiping, swirling, dotting, and trailing.

SUGGESTIONS AND VARIATIONS Children should work directly on the paper. NO PENCILS, PLEASE! Repeat the above procedure, but this time wet the paper first.

Spatter Painting

SUPPLIES

- Tempera
- Small piece of wire screen with edges taped
- Newsprint
- Toothbrush or sponge
- Drawing paper

PROCEDURE

1. Tape drawing paper to newsprint.
2. Dip a sponge or brush in small amount of paint.
3. Force the paint through the screen by rubbing the brush or sponge back and forth.
4. Build up whole pictures of spatters with different colors.

SUGGESTIONS AND VARIATIONS Cut out and arrange paper shapes, like stencils, on painting paper. Then use spattering to create designs. Stencils may be holiday-oriented, such as hearts, snowflakes, turkeys, and so on.

SUPPLIES

- Tempera
- Paintbrush or spoon
- Drawing paper

PROCEDURE

1. Fold a piece of drawing paper in half.
2. Using a brush or spoon, place drops of tempera of one or more colors on one side of the paper or on the fold. Gently press the halves of the paper together so that the paint will squeeze and blot.
3. Open paper and allow to dry.

SUGGESTIONS AND VARIATIONS
Children will enjoy creating a class mural. Have them make several blotter paintings of different sizes and cut them out. Roll out a long sheet of paper and tape it to the chalkboard. Have each child paste his or her "blotto" to the paper. Discuss size variations (small and large) and contrast (light and dark).

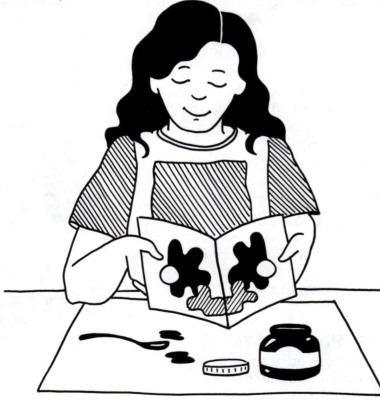

Watercolor Wax Resist

SUPPLIES

- Watercolor paint
- Drawing paper
- Pencil or paintbrush
- Wax paper
- Tape

PROCEDURE

1. Tape wax paper over drawing paper.
2. Draw heavily on the wax paper with a pencil or the wooden end of a paintbrush. Pressure will transfer the wax to the drawing paper.
3. Remove wax paper and paint over the drawing with watercolors. The lines drawn with wax will remain white.

Rubber Cement Resist

SUPPLIES

- Watercolor or thinned tempera
- Drawing paper
- Rubber cement
- Soft cloth or eraser

PROCEDURE

1. Use the brush in the rubber cement jar to make a design on paper.
2. After the rubber cement dries, paint across it with watercolor or thinned tempera.
3. After the paint dries, remove the rubber cement by rubbing with a soft cloth or eraser. White spots will appear. This process may be repeated several times over the same piece of paper.

SUGGESTIONS AND VARIATIONS Choose at least two colors, one light and one dark. On the paper, draw a simple design with the rubber cement. Cover the paper with the lightest color of paint and let dry. Choose those painted areas you wish to preserve and cover them with rubber cement. Paint the paper with the darker color and let dry. Remove the rubber cement.

SUPPLIES

- Tempera
- Drinking straws
- Drawing paper
- Paintbrush or spoon

PROCEDURE

1. Drop or dribble blobs of tempera on the paper with a brush or spoon.
2. Blow through a straw to make several different designs and patterns.

SUGGESTIONS AND VARIATIONS Try this activity with dark paint on white or light construction paper. Then try it using white paint on dark construction paper.

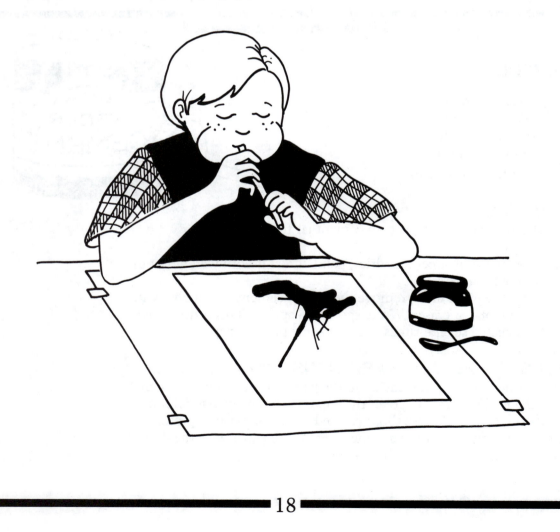

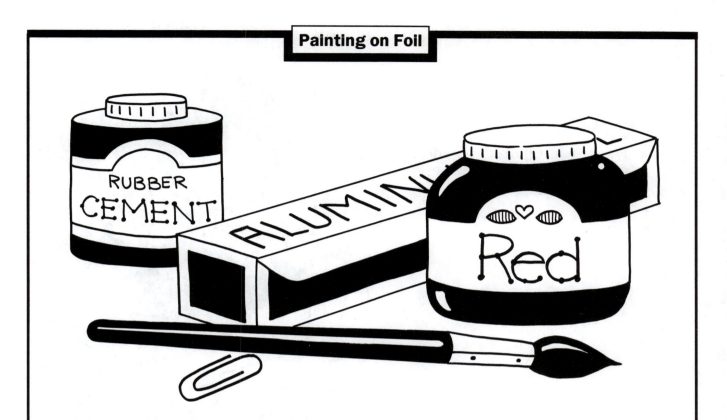

SUPPLIES

- Aluminum foil
- Rubber cement
- Tempera
- Cardboard
- Paintbrush
- Scratching tool, such as an unbent paper clip
- Liquid detergent
- Clear spray

PROCEDURE

1. Coat one side of both the aluminum foil and the cardboard with rubber cement and allow to dry.
2. Press both rubber-cemented sides together and smooth out any wrinkles.
3. Paint the surface of the foil with tempera. If paint begins to bead up, add a few drops of liquid detergent. Allow to dry.
4. Scratch a picture or design through the paint.
5. Spray the finished surface with a commercial transparent spray to prevent the surface from cracking.

SUPPLIES

- Finger paint (jarred, powdered, or homemade—see recipes)
- Glossy or glazed paper
- Sponge
- Iron
- Clear spray

PROCEDURE

1. Wet both sides of paper either by placing it under a faucet or soaking with a wet sponge.
2. Place the paper, glossy side up, on a smooth, flat surface. A washable floor is a great place for children to work.
3. Smooth out all wrinkles and air bubbles.
4. Place about 1 tablespoon of jarred finger paint on the paper. (If powdered paint is used, sprinkle it lightly over the entire paper.) If paint is applied too heavily, it will chip or crack when it dries.
5. Spread the paint over the entire sheet of paper. Use the palm of the hand or the forearm to create the background.
6. If paint becomes too sticky, add a few drops of water to the surface. This will allow the hand to move smoothly over the paper.
7. Allow to dry. Press with iron on the unpainted side. For safety reasons this step must be teacher-supervised.
8. Spray a clear fixative over the painting and let dry.

DRY STARCH RECIPE

SUPPLIES

- Dry laundry starch
- Water, hot plate or stove, pot, and spoon
- Containers
- Pigment: tempera or food coloring

PROCEDURE

1. Dissolve 1 cup (250 ml) dry starch in 4 cups (1 liter) water.
2. Cook until mixture is clear, stirring constantly. If mixture appears too thick, add water gradually.
3. Pour mixture into containers, one for each color, and add desired pigments.
4. Mix again and let cool. Store in a cool place.

LIQUID STARCH RECIPE

SUPPLIES

- Soap flakes
- Liquid laundry starch
- Spoon
- Containers
- Pigment: tempera or food coloring

PROCEDURE

1. Add soap flakes to 1 quart (1 liter) liquid starch. Stir.
2. Pour mixture into containers, one for each color.
3. Add desired pigments and mix again. About 1 teaspoon (5 ml) of tempera is adequate for each quart (liter) of mixture.

WHEAT PASTE RECIPE

SUPPLIES

- Wheat paste or wallpaper paste
- Water
- Spoon
- Containers
- Pigment: tempera or food coloring

PROCEDURE

1. Add water to paste until it reaches desired consistency.
2. Mix well and pour into containers, one for each color.
3. Add desired pigment and mix again.

SUPPLIES

- Finger paint, powdered or jarred
- Glossy or glazed paper
- Tongue depressor or piece of cardboard
- Thin stencil material such as paper, leaves, string, or cloth
- Water

PROCEDURE

1. Cut stencil material into imaginative shapes.
2. Place shapes on a smooth, flat surface.
3. Wet paper and place it glossy side up over the arrangement of stencil material.
4. Place 1 tablespoon of jarred paint on the wet surface. (If using powdered paint, sprinkle lightly over entire paper.)
5. Use your hand or forearm to spread paint evenly over the paper to achieve a background.
6. Pull a tool with a straight edge, such as a tongue depressor or piece of cardboard, over the entire paper. An impression of the stenciled shapes will appear on the paper.

SUPPLIES

- Powdered tempera
- Drawing paper
- Liquid laundry starch
- Crayons

PROCEDURE

1. Make a design on drawing paper with bright crayon.
2. Place the paper on a smooth, flat surface.
3. Pour and spread liquid starch over the crayon design.
4. Choose a paint color that contrasts with the crayon color and sprinkle a small amount over the starch.
5. Finger-paint over the crayon design. Color will mix as hand motions begin.

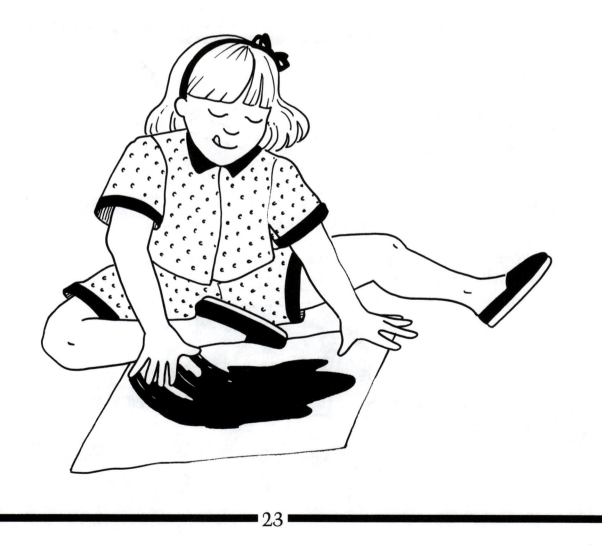

Painting with Twigs

SUPPLIES

- Tempera
- Drawing paper, large and small
- Twigs and sticks of various sizes
- Scissors

PROCEDURE

1. Dip twigs and various types of sticks, such as tongue depressors or ice-cream sticks, in paint.
2. Use the twigs and sticks as paintbrushes to create different effects on small pieces of paper.
3. Experiment with the sticks by cutting or breaking the flexible ones. For instance, a split stick will make a double line.
4. Make pictures using different twigs and sticks.

Tempera and Crayon Loops

SUPPLIES

- Black tempera
- Paintbrushes
- Drawing paper
- Crayons

PROCEDURE

1. On large paper, use a brush and black tempera to make large, sweeping loops.
2. When the tempera dries, fill in the loops with beautiful designs using bright crayons.

SUPPLIES

- Transparent watercolors
- Soft watercolor brush
- Drawing paper
- Paper towels or sponge
- Water

PROCEDURE

1. Wet the drawing paper with a sponge. Blot up excess water.
2. Dip the brush in the watercolors and try different painting techniques directly on wet paper. Use quick, dotting strokes; drag the brush to create long strokes. Paint will blend into soft spontaneous shapes.
3. Make several different paintings.

SUGGESTIONS AND VARIATIONS For older students, try placing a few drops of India ink on the dry watercolor painting. Take a straw and blow ink across the design to make patterns. Black ink creates a beautiful silhouette against a background of soft watercolors. Achieve a similar effect by cutting and pasting black construction-paper silhouettes to the painting. Have students look for recognizable forms in the painting. Clarify the forms by adding details with pen and black ink or with black felt-tip markers.

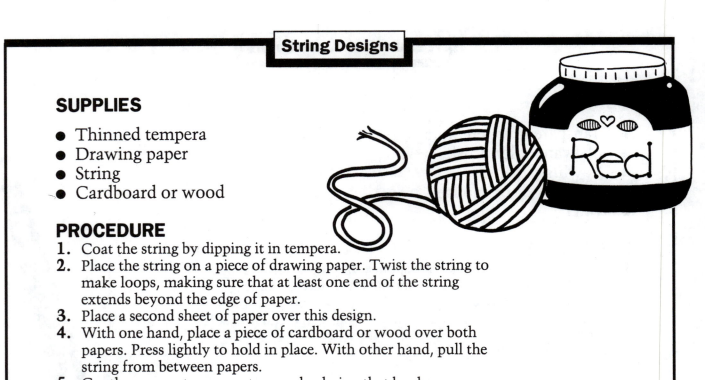

SUPPLIES

- Thinned tempera
- Drawing paper
- String
- Cardboard or wood

PROCEDURE

1. Coat the string by dipping it in tempera.
2. Place the string on a piece of drawing paper. Twist the string to make loops, making sure that at least one end of the string extends beyond the edge of paper.
3. Place a second sheet of paper over this design.
4. With one hand, place a piece of cardboard or wood over both papers. Press lightly to hold in place. With other hand, pull the string from between papers.
5. Gently remove top paper to reveal a design that has been duplicated on the second sheet of paper.

SUGGESTIONS AND VARIATIONS The procedure may be repeated with more than one color. Place string inside a folded paper. Pull the string across the paper to make a design.

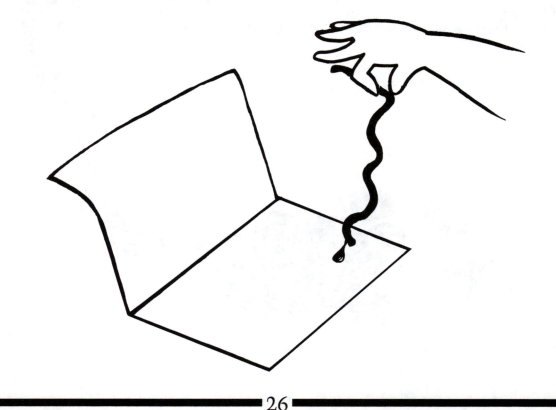

Watercolor Crinkles

SUPPLIES

- Transparent watercolors
- Soft watercolor brushes
- Shelf paper, typing paper, or other glazed paper
- Iron
- Newspaper

PROCEDURE

1. Dip the paper in water and crinkle it into a tight ball.
2. Open up the paper and smooth it out on a flat surface.
3. While still damp, cover the paper with one shade of watercolor. Creases will absorb more color than will smooth areas. A pattern that has dark jagged lines against a lighter background will result.
4. Allow the paper to dry and place it between layers of newspapers. Iron until paper becomes smooth.

Invisible Pictures

SUPPLIES

- Transparent watercolors
- Soft watercolor brushes
- White crayon or paraffin
- Drawing paper

PROCEDURE

1. Draw a picture on drawing paper, using white crayon or paraffin.
2. Have children exchange pictures. (The white crayon or paraffin picture remains almost invisible.)
3. Paint the whole paper using one shade of watercolor. Watch an "invisible" picture appear.

SUPPLIES

- Transparent watercolors
- Soft watercolor brushes
- Newsprint or thin watercolor paper

PROCEDURE

1. Make a fold across the paper, about one third up from the bottom.
2. Open the paper. Using the fold as a base or horizon line, paint a watercolor landscape in the top two thirds of the paper. Choose subject matter that includes a body of water or a rainy-day scene.
3. While the paint is still wet, fold up the bottom third of the paper and press it gently onto wet painting.
4. Open up the bottom flap and discover that colors from the top have been duplicated on the bottom. This creates the illusion of a scene reflected in water.
5. Let dry. Additional details now may be added to the top scene to enhance the illusion.

From their prekindergarten scribbles to their more sophisticated drawings of later years, most children have experienced the excitement of drawing as a natural means of self-expression. The following activities will broaden children's drawing experiences by exploring a variety of drawing materials (including crayons, chalk, pencils, pen and ink, felt-tip pens, tempera, transparent watercolors, textiles, and a variety of art papers) and by developing effective techniques for their use. Children will have fun while creating expressive pictures and designs.

SUPPLIES

- Thick, peeled crayons
- Thin, pointed crayons
- Manila drawing paper

PROCEDURE

1. Experiment with different drawing strokes using a thick, peeled crayon. Try dragging, twisting, and turning the side of the crayon. Try to build up layers of crayon, one over another. Change the amount of pressure to achieve color variations.
2. Experiment with the point of a thin crayon. Variations in line widths and color intensities may be achieved by applying different degrees of pressure to the crayon.
3. Make a beautiful design or picture using broad and thin stroke techniques.

SUGGESTIONS AND VARIATIONS

Try many different strokes to achieve various shading effects such as stippling and crosshatching.

stippling

crosshatching

SUPPLIES

- Thick, peeled crayons
- Drawing paper, light or medium weight
- Textured objects
- Tape

PROCEDURE

1. Tape or hold drawing paper over the surface of a textured object. Experiment with a variety of objects, such as cut and torn paper shapes, natural objects (leaves or flowers), string, coins, and so on.
2. Rub the side of a thick, peeled crayon over the paper. The textured design will appear.
3. Experiment further by making rubbings of various classroom textures, such as walls, floors, or bulletin boards. Go outdoors and make rubbings of textures such as concrete, bricks, fencing, tree bark, and so on.

SUGGESTIONS AND VARIATIONS Have children draw directly with crayon on sandpaper. Textural effects will vary with different grades of sandpaper—fine, medium, or coarse.

Texture Pictures

SUPPLIES

- Crayons, thick and thin
- Pencils
- Large manila drawing paper
- Textured surfaces

PROCEDURE

1. Using a pencil or thin crayon, make an outline drawing on manila paper.
2. Find a surface with a definite texture, such as a bulletin board. Hold the paper over the texture and rub the side of a thick crayon over the areas on which this texture should appear.
3. Find other textured surfaces, such as cardboard, fabric, sandpaper, and so on. Rub and transfer these textures to different parts of the picture.

SUPPLIES

- Crayons, thick or thin
- Manila drawing paper
- Thinned tempera, transparent watercolor, or ink
- Wide paintbrushes

PROCEDURE

1. Make a design on the paper with crayon. Use bright colors and make sure to leave some white areas.
2. Dip a large brush in thinned tempera, watercolor, or ink. Dark colors, especially black, are most effective. Wash over the entire crayoned area. The wax of the crayon will resist the paint or ink. In the white areas the paint will be absorbed. This contrast will create an interesting and powerful effect.

Crayon Engraving

SUPPLIES

- Crayons, thick or thin
- Drawing paper, white or manila
- Tool for scraping, such as an open paper clip
- Tissue or soft cloth

PROCEDURE

1. Make a design on an entire sheet of drawing paper using a heavy coat of brightly colored crayons. Avoid dark colors. A definite design or planned drawing is not necessary.
2. Color over the entire design using a dark crayon such as black or purple.
3. Rub the crayoned surface gently with a piece of tissue or soft cloth. This will help the dark crayon stick to the bright surface.
4. Scrape a design or picture into the dark surface using an open paper clip. Make sure to scratch through to reveal the bright design underneath.

Crackled Paper and Crayon Resist

SUPPLIES

- Crayons, thick and thin
- Manila drawing paper or brown wrapping paper
- Transparent watercolors
- Paintbrushes

PROCEDURE

1. Make a drawing on manila or brown paper using a light crayon. Draw lines and shapes, leaving areas of paper to show through.
2. Crumple the paper into a small ball.
3. Open paper and smooth out.
4. Paint the entire paper with transparent watercolor, using one or more colors. The wax crayon will resist the paint; the unpainted areas as well as some of the crackles will absorb it. The result will be a design with a weblike pattern of crackles.

Crayon Glazes

SUPPLIES

- Crayons, thick or thin
- White drawing paper
- Straight-edge scraping tool

PROCEDURE

1. Make a design or picture on drawing paper by pressing heavily with crayons.
2. Scrape off crayon with a straight-edge tool. Younger children can use a tongue depressor or craft stick. Older children, *carefully instructed and supervised,* may have better success with a single-edge razor blade. A soft crayon design with transparent films of color will remain on the surface.

SUPPLIES

- Peeled crayon stubs or encaustic paint (see recipes)
- Old muffin tin
- Electric hot plate
- Stiff-bristle brushes
- Heavy paper or durable painting surface
- Soap

PROCEDURE

1. In each section of a muffin tin, place the stubs of crayons that have been grouped according to color.
2. Heat the muffin tin on the hot plate to melt the crayons. Keep the tin hot so that crayons remain liquid.
3. Paint directly on paper or other surface with a brush dipped in the hot, melted crayons. If crayons cool, reheat.
4. Experiment with different colors and brush strokes. Encaustic painting yields unique effects of texture, tone, and brilliance.
5. Clean brushes with hot soapy water. Hereafter, these brushes should be confined to working with wax or melted crayon.

SUGGESTIONS AND VARIATIONS Extreme caution should be exercised around heating elements and electric cords. Make sure hot plates and tins are secure and will not tip over. Keep electric cords away from classroom traffic.

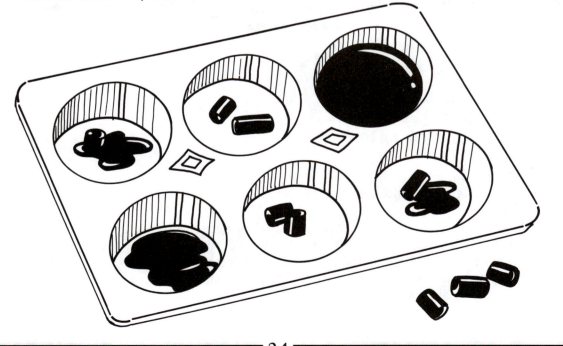

In encaustic painting, the artist uses heated wax that contains pigment. Two methods of making your own encaustic paints follow.

METHOD I

SUPPLIES

- 1 ounce (28 g) beeswax
- Hot plate
- Double boiler
- 2 teaspoons (10 ml) dry tempera or pigment
- Wooden spoon

PROCEDURE

1. Heat beeswax in a double boiler over a hot plate.
2. Add pigment and stir with a wooden spoon.

METHOD II

SUPPLIES

- Crayons
- Sharpened tool
- Muffin tin
- Turpentine
- Wooden spoon or stick

PROCEDURE

1. Using a sharpened tool, such as scissors or a single-edge razor blade, shave crayons into fine pieces.
2. Sort by color in muffin tin.
3. Soak each color shaving in turpentine for twelve to fifteen days. The finer the shavings the more quickly they will dissolve. Stir with wooden spoon or stick until a smooth, creamy consistency is achieved.

 NOTE: Use extreme caution in handling turpentine. Keep it away from classroom traffic. Make sure your work area is well ventilated.

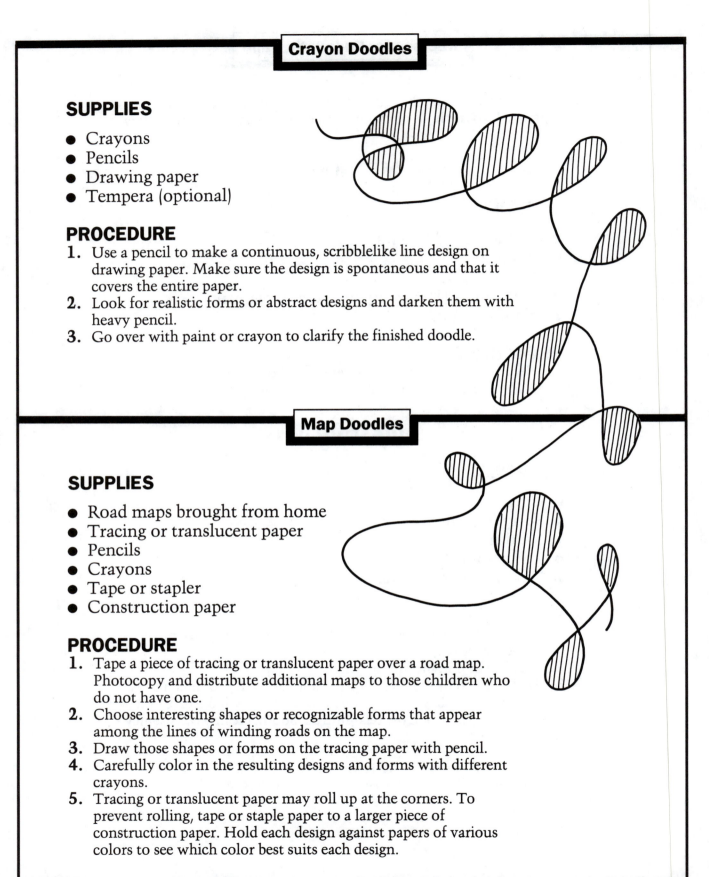

Crayon Doodles

SUPPLIES

- Crayons
- Pencils
- Drawing paper
- Tempera (optional)

PROCEDURE

1. Use a pencil to make a continuous, scribblelike line design on drawing paper. Make sure the design is spontaneous and that it covers the entire paper.
2. Look for realistic forms or abstract designs and darken them with heavy pencil.
3. Go over with paint or crayon to clarify the finished doodle.

Map Doodles

SUPPLIES

- Road maps brought from home
- Tracing or translucent paper
- Pencils
- Crayons
- Tape or stapler
- Construction paper

PROCEDURE

1. Tape a piece of tracing or translucent paper over a road map. Photocopy and distribute additional maps to those children who do not have one.
2. Choose interesting shapes or recognizable forms that appear among the lines of winding roads on the map.
3. Draw those shapes or forms on the tracing paper with pencil.
4. Carefully color in the resulting designs and forms with different crayons.
5. Tracing or translucent paper may roll up at the corners. To prevent rolling, tape or staple paper to a larger piece of construction paper. Hold each design against papers of various colors to see which color best suits each design.

SUPPLIES

- Peeled crayons
- Cheese grater
- Wax paper
- Colorful yarn or thread
- Construction paper
- Iron
- Newspaper
- Tape or stapler

PROCEDURE

1. Using a cheese grater, grate different colors of crayon shavings onto a sheet of wax paper.
2. Make an interesting design by scattering shavings across the paper.
3. Add interest to the design by placing colorful pieces of looped yarn or thread among the shavings.
4. Cover with a second sheet of wax paper.
5. Place the two sheets of wax paper between protective layers of newspaper.
6. Iron at medium heat, pressing gently to fuse the wax paper and melt the crayon shavings. Too much heat or pressure will cloud the design.
7. Cut out the centers of two pieces of construction paper. Make a frame with the borders.
8. Tape or staple borders to frame the design.

Crayon Stencils

SUPPLIES

- Crayons
- Scissors
- Heavy paper
- White drawing paper
- Pencils with erasers

PROCEDURE

1. Using scissors, cut a silhouette shape from heavy paper.
2. Color the edges of the silhouette by applying heavy crayon.
3. Use the silhouette as a stencil by placing it on white drawing paper. Hold down the silhouette with one hand. Take a pencil eraser in the other hand and use it to smudge the crayoned border onto the white paper. Smudge crayon in an outward motion.
4. Continue this process using other silhouettes and different color crayons.

SUGGESTIONS AND VARIATIONS Make realistic pictures by cutting out silhouettes of familiar objects such as trees, flowers, and houses. Create a whole picture with crayon stencils.

Crayon on Wallpaper

SUPPLIES

- Wallpaper scraps or sample books
- Crayons

PROCEDURE

1. Bring in scraps of wallpaper or have children bring them in from home. Old wallpaper sample books may be readily available at neighborhood wallpaper stores without charge.
2. Distribute to children scraps that are precut into workable sizes. Let each child choose one or two different patterns.
3. With crayon, draw a picture or design directly on the wallpaper. Try to use a crayon design or picture that can be integrated into the wallpaper pattern. For instance, patterns that are solely textural may lend themselves to landscapes or cityscapes. A large-scale pattern with a solid background and long wispy lines may suggest a rainstorm in which figures and background objects may be drawn. Use your imagination and have fun!

SUPPLIES

- Crayons
- Plain paper
- Iron
- Plain cotton fabric

PROCEDURE

1. Make sure all sizing has been removed from cotton by washing it in hot water and allowing it to dry prior to the activity.
2. Use varying degrees of pressure on crayons to draw directly on fabric.
3. To make design permanent, use a warm iron to melt crayon into cotton. Press design between two sheets of plain paper. When the drawing can be seen on the back side of the fabric, it is finished.

Crayon Transfers

SUPPLIES

- Crayons
- Drawing paper
- Pencils or ballpoint pens

PROCEDURE

1. With crayon, make a colorful design on drawing paper, covering the entire paper. Be sure to use heavy pressure on the crayon to make a thick and rich design.
2. Place a second piece of drawing paper on a flat surface.
3. Place the colorful design on top of the second paper, crayon side down.
4. Draw a design or picture on the back of the colorful crayon design with a pencil or ballpoint pen. The picture will transfer in colorful lines to the bottom sheet of paper.

SUPPLIES

- Crayons
- Drawing paper
- Pencils
- Straight-edge tool
- Oil, cooking or linseed
- Turpentine
- Container
- Paper towels
- Rulers and compasses

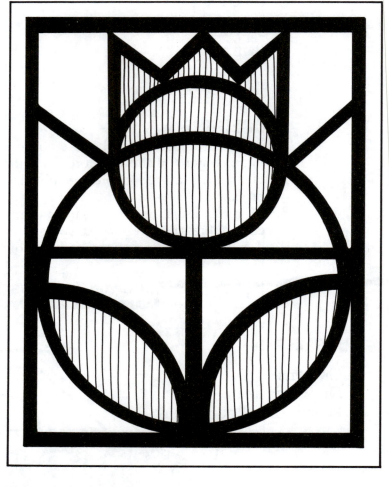

PROCEDURE

1. Discuss and show examples of stained-glass windows.
2. With a pencil, draw a design on drawing paper. Some children may be able to use compasses and rulers to create true geometric designs common in many stained-glass windows.
3. Go over pencil lines with heavy black crayon. Using equally heavy pressure, color in remaining shapes in bright colors.
4. Carefully scrape off crayon using a straight-edge tool such as a tongue depressor or craft stick.
5. Recolor the black lines using heavy pressure and a black crayon.
6. Make a mixture of half turpentine and half linseed or cooking oil. A tin can is a handy container.
7. Dip one end of a paper towel in the mixture and wipe it over the back of the design.
8. Blot off excess oil with another paper towel and allow to dry. The oil mixture gives the design a translucency similar to the effect of stained glass.

SUPPLIES

- Crayons, thin
- Drawing paper
- Magazines
- Scissors
- Paste

PROCEDURE

1. From magazines, cut out photographs of faces. Photographs should be large and show frontal face. Cosmetic or fragrance ads are perfect for this activity. In classes where proficiency with scissors is limited, it may be necessary to precut photographs.
2. Paste the left side of the face lengthwise on the left side of the drawing paper. Make sure paper is held vertically.
3. Have each child use a crayon to draw in matching features on the right side of the paper.

LIFE-SIZE PORTRAITS

SUPPLIES

- Brown wrapping paper, large sheets
- Scissors
- Crayons

PROCEDURE

1. Move desks to clear a large floor space.
2. Place a large sheet of brown paper on the floor. Have the class gather around while one child makes a crayon outline of another child who is lying on his or her back on top of the paper.
3. Have partners take turns lying down and outlining on brown paper.
4. Have children cut out these life-size portraits and color them with crayon, making sure to add realistic facial features and clothing.

41

SUPPLIES

- Pencils
- Drawing paper, white or manila, large and small
- Crayons or oil-based crayon pastels
- Mirror(s)
- Charcoal or white chalk

PROCEDURE

1. Discuss portraits in terms of facial proportions. On the chalkboard, draw the shape of the head—oval or egg-shaped. Have children use one another for visual clarification. Draw a line to divide the face lengthwise, emphasizing its symmetry. Draw other lines to indicate facial proportions. The eyes are halfway from the top of the head to the chin. The nostrils are one-half the distance from the eyes to the chin. The mouth is one-third the distance from the nostrils to the chin. The eyes are about a width of an eye apart. Discuss features that make people look different, such as sizes and shapes of eyes, noses, lips, and ears, and colors of hair, eyes, and skin.

2. Have children use small manila drawing paper to draw a self-portrait based on these guidelines. Distribute hand mirrors to groups of children to use for visual reference.

3. Have children draw another self-portrait on larger paper using crayons or pastels. It is preferable to use pastels if available, as oil-based color is more brilliant than crayon. Encourage children to make undetailed preliminary sketches using charcoal or chalk. This will help them place facial features correctly before completing the portrait with permanent color.

SUGGESTIONS AND VARIATIONS Display finished portraits on a bulletin board in a school corridor. Entitle it "Anyone You Know?" Children of all ages will be thrilled to search the bulletin board for familiar faces.

Exploring Chalk

SUPPLIES

- Chalk
- Gray construction paper
- Clear fixative, commercial or homemade
- Atomizer or plant mister
- Cotton swabs or tissues

PROCEDURE

1. Experiment with the vivid effects of chalk on dark and medium gray construction paper. When using dark paper, suggest light subject matter, such as snow scenes, spring flowers, or white furry animals.
2. Demonstrate the effects of blending tone and color by rubbing chalk areas with fingers, cotton swabs, or tissues. Point out the different contrasts made by using light and dark chalks on light and dark papers.
3. Make a picture with chalk on construction paper.
4. Protect the completed work with clear fixative, a spray that prevents chalk from smearing. Spray the fixative in a well-ventilated area. If a commercial spray is too expensive or unavailable, try making one. Dissolve gum arabic (available in art supply stores) in water. A thin, creamy consistency is necessary for maximum efficiency. Spray with atomizer or plant mister.

Wet Chalk Pictures

SUPPLIES

- Newsprint
- Chalk
- Water
- Sponge

PROCEDURE

1. Have each child wet his or her paper by spreading water over it with a wet sponge.
2. While paper is still damp, quickly and carefully make a design or picture using chalk. The wet paper intensifies the chalk colors.

SUGGESTIONS AND VARIATIONS Another method requires using dry and heavy construction paper and wet chalk. Draw a picture with dry colorful chalk on dry paper. Then dip chalk in any of the following liquids: sugar water (1 teaspoon [5 ml] sugar to 2 cups [500 ml] water), liquid starch, powdered milk diluted with water, plain water, mineral spirits, or turpentine. Fill in some areas using wet chalk. Soaking chalk for a longer time will help resist smudging. Use a fixative if necessary.

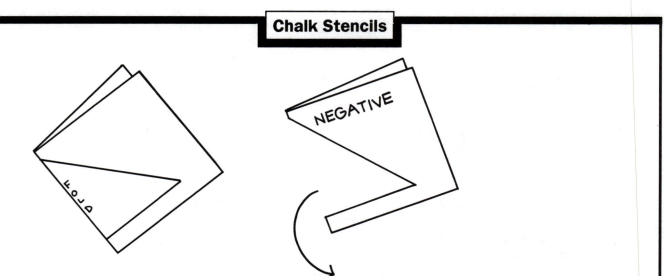

SUPPLIES

- Stencil paper, oaktag or old file folders
- Chalk
- Scissors
- Cotton swabs or tissues
- Drawing paper
- Pencils

PROCEDURE

1. Fold small pieces of stencil paper in half.
2. With a pencil, draw half a shape on the fold.
3. Cut out the shape and then discuss the concept of positive and negative space and shapes. The cutout shape is the positive stencil or space. The section containing the opening is the negative stencil or shape. Use either or both to make a design.
4. Put a positive or negative stencil on drawing paper and hold it in place with one hand. With the other hand, draw around or inside the shape with chalk.
5. Holding onto the stencil, brush chalk with fingers, cotton swabs, or tissues. When using positive stencil, brushing strokes should move from the inside of the shape to the outside onto the drawing paper. When using negative stencil, brush from the outside of the opening inward.
6. Repeat this procedure to make a design. Experiment with various stencils, positive and negative, and overlapping stencils, and with different colors of chalk.

SUPPLIES

- Chalk
- Sandpaper, various grades

PROCEDURE

1. With chalk, draw a picture directly on sandpaper.
2. Experiment with different grades of sandpaper to achieve different textural effects.

SUGGESTIONS AND VARIATIONS Vary textural effects by placing drawing paper over textured surfaces and rubbing the chalk, broadside, over the paper.

Chalk Drawing to Music

SUPPLIES

- Two or three contemporary songs (record, tape, or compact disc)
- Record player, cassette player, or compact disc player
- Chalk
- Construction paper, medium-toned

PROCEDURE

1. Play a short section of a song that tells a story. Discuss with children the content of the story. Explain that musicians tell stories using words and sounds, authors tell stories with words, and artists tell stories with lines, shapes, and colors. Talk about colors that express moods. Warm colors—yellow, red, and orange—express feelings of excitement or joy. Cool colors—blue, green, and violet—express feelings of sadness, loneliness, or mystery.
2. Now play a section of distinctly happy or sad music. "Good Day Sunshine" by the Beatles is a good example of a happy song.
3. Distribute chalk and paper and have children make a design or picture that expresses the mood of the song.

SUPPLIES

- Chalk
- Drawing paper
- String
- Thumbtacks
- Soft wooden board or bulletin board covered with newspaper

PROCEDURE

1. Place a soft wooden board on a flat surface. If a wooden board is not available, cover bulletin board with a protective layer of newspaper and allow children to stand while working.
2. Press a thumbtack into the board near the top. Tie one end of a piece of string around the tack.
3. Insert a piece of drawing paper under the string and tack it down.
4. Rub chalk up and down the string, making sure it is thoroughly coated with chalk dust.
5. With one hand, pull the string down tightly across the paper. With the other hand, pull the string back and release, snapping it against the paper. Make different lines using various string directions and with different-colored chalk.
6. Change the position of the paper and try again.
7. Spray the finished design with fixative.

SUGGESTIONS AND VARIATIONS Experiment with changes in color. Shade areas by brushing chalk lines with fingers. Color in shapes between chalk lines to create interesting designs and patterns.

SUPPLIES

- Wide charcoal
- Drawing paper, newsprint, manila paper, or toned construction paper
- Cube and ball

PROCEDURE

1. Experiment with technique by using the tip and broad side of the wide charcoal on drawing paper. Wide charcoal instead of vine charcoal is recommended for use in the elementary grades.
2. Discuss shading in terms of a light source and flat and curved surfaces. Curved objects should be shaded gradually from light to dark. Objects with flat surfaces should have a side that is uniformly dark.

3. Set up a cube and a ball. Make sure a source of light is available. Have children draw and shade one object on small drawing paper.
4. On larger paper, draw a whole picture using charcoal. Shade areas that require strong contrasts of light and dark. Highlight some areas by leaving them untouched. When toned paper is used, use white chalk to accent highlights.

SUPPLIES

- Ink in jar, dark color
- Pen holders and points, if available
- Brushes
- Soft twigs and sticks
- White drawing paper

PROCEDURE

1. Ink is one of the most expressive drawing materials. Try different line techniques by using different size pen points. Also try a combination of strokes to create stippling and crosshatching.
2. Experiment further by using different types of brushes. Try hard-bristle brushes, both narrow and wide. Try brushes that are full or sparsely haired. Soft-bristle brushes of many sizes and widths render beautiful flowing lines. Try moving the whole arm, not just the fingers or wrist.
3. Experiment by using soft, absorbent twigs or sticks as brushes. Choose a soft stick, such as a used matchstick or lollypop stick. Dip the stick in ink and hold it over jar opening until excess ink drips off and the stick becomes saturated. Use the various sticks as you would use a pen or brush. You can create different effects by using sticks with sharp points, broad edges, and smooth or frayed ends.

SUGGESTIONS AND VARIATIONS Combine ink with other media. Ink contrasts beautifully with watercolors, tempera, or crayon. It can also provide clarifying details on other pieces of work. Experiment with ink on wet paper.

SUPPLIES

- Crayons, ink, or felt-tip pens
- Drawing and manila paper, small
- Pencils
- Newspaper or other protective covering

PROCEDURE

1. Discuss advertising in terms of favorite television commercials or print ads. Explain that commercial artists use line, shape, and color to express an idea.
2. On the chalkboard, draw examples of words that "look like" what they mean. Here are some examples:

FAT THIN LONG or WIDE

Make sure to alter the shape of the letters in some way to fit the meaning of the word. Clever and humorous examples will inspire children's creativity.

3. Distribute small manila drawing paper and pencils. Have children choose many different words to illustrate in expressive lettering.
4. Circulate around the room or have individual children come to your desk with their work. Encourage creative imagination in their expressive lettering.
5. Use a pencil and a second piece of manila paper to enlarge the chosen word. Show children how to transfer the enlarged word onto white drawing paper. Turn over the manila paper with the enlarged word and blacken the back with the side of the point of a pencil. Make sure desks are covered with newspaper or other protective covering. Place the blackened side on top of clean white drawing paper. Go over the word by outlining again with pencil on manila paper. A carbonlike copy of the word will appear on the white drawing paper.
6. Finish expressive lettering with crayon, felt-tip pens, or pen and ink.

You have now introduced children to a wide variety of painting and drawing activities. The next area to explore is crafts, which involves a variety of mixed media. Most of the previous activities have been two-dimensional in nature. Now it's time to have fun with two- and three-dimensional crafts, involving cut-and-torn paper, collage, printmaking, clay, papier-mâché, and other media. With a solid background of painting and drawing techniques as well as a full understanding of design principles, children are prepared to use their imaginations to the fullest.

Most activities use supplies that are available in most classrooms, that can be gathered from nature, or that children can find at home and bring to school.

SUPPLIES

- Thin paper
- Construction paper
- Rubber cement
- Scissors

PROCEDURE

1. Fold a thin piece of paper in half, horizontally and vertically, into a small piece. Make sure folded paper does not become too thick to cut with scissors.
2. Cut away different small shapes from the folds and edges. The more paper that is cut away, the more interesting the finished design will be.
3. Unfold the paper, taking care not to tear it.
4. Use rubber cement to mount the finished design on a contrasting color of construction paper.

SUGGESTIONS AND VARIATIONS Take this activity one step further by placing and gluing other colorful cut shapes on the construction paper before gluing down the final design. If a perfect white square is used, the finished designs will look like snowflakes. Decorate the windows or hang with string to create an attractive winterlike environment.

Geometric Designs

SUPPLIES

- Construction paper
- Scissors
- Paste

PROCEDURE

1. Choose a number of colorful construction papers.
2. Discuss geometric shapes—circles, squares, triangles, and rectangles. Cut geometric shapes in various sizes and colors out of the construction paper. Experiment by cutting some shapes in halves, quarters, and thirds.
3. Choose a background paper of a contrasting color. Move shapes around on the background paper until they form a pleasing design or picture.
4. Paste shapes in place.

SUPPLIES

● Construction paper
● Scissors
● Crayons
● Paste

PROCEDURE

1. Fold a piece of construction paper in half horizontally.
2. Beginning at the fold, write your name in script with a crayon. Spread out the letters and make them thick enough to be cut on both sides of the line.

Make sure each letter touches the fold. However, certain letters such as *f, g, j, p, q, y,* and *z* extend below the line. Those letters must be written above the fold with only the extensions touching.

3. Cut out the name on both sides of the wide script line. Make sure that some, if not all, of the letters are held together by the fold.

For younger children, have each child write a name with only the first letter touching the fold. Designs will vary due to differences in penmanship and lengths of names.

4. Open the design and paste onto contrasting construction paper.

SUPPLIES

- Construction paper
- Scissors
- Paste

PROCEDURE

1. Choose two pieces of construction paper in contrasting colors.
2. Fold one sheet in half and cut slits of about 1 inch (2 1/2 cm) from the fold to 1 inch (2 1/2 cm) below the top edge.
3. Cut 1 inch × 17 inch (2 1/2 cm × 43 cm) strips from the other piece of construction paper.
4. Unfold the paper and weave the strips through the cut slits of the first paper, going over and under to make a design. Hold strips in place with paste, if necessary.

SUGGESTIONS AND VARIATIONS Vary your pattern by cutting strips from magazines, wallpaper, and different construction paper. Vary the shapes of the cut lines to change the weaving pattern.

Positive and Negative Designs

SUPPLIES

- Construction paper
- Scissors
- Paste or rubber cement
- Pencils

PROCEDURE

1. Use a full sheet of construction paper and a half sheet of a contrasting color.
2. Fold the smaller sheet in half vertically. Draw and cut out a simple shape from the folded side. The cut shape is the positive design; the paper containing the empty shape is the negative design.
3. Unfold and paste the negative design on one side of the larger sheet of paper. Make sure to match up the corners.
4. Center and paste the positive shape on the other side of the larger paper.

SUGGESTIONS AND VARIATIONS A variety of patterns can be discovered by cutting and alternating positive and negative pieces.

TWO-DIMENSIONAL

SUPPLIES
- Construction paper
- Scissors
- Paste

PROCEDURE
1. Using a variety of construction paper, cut strips 1/8 inch to 1/2 inch (3 mm to 12 mm) wide. For younger children, it may be necessary to precut the strips.
2. Choose a piece of contrasting construction paper for the background. Place strips of varying widths and lengths on the background and arrange until a pleasing design or picture is formed.
3. Paste strips into place.

THREE-DIMENSIONAL

SUPPLIES
- Construction paper
- Scissors
- Paste
- Clear tape

PROCEDURE
1. Using a variety of construction paper, cut paper strips 1/4 inch to 1/2 inch (6 mm to 12 mm) wide.
2. Make strips into shapes by taping or gluing the ends together. Experiment with many widths and lengths to create different shapes. Try curling, folding, and pleating the strips.
3. Choose a piece of contrasting construction paper for the background. Arrange different strip shapes on the background until a colorful design or picture is formed.
4. To fasten, apply paste to one edge of strip shapes and press gently in place.

SUPPLIES

- Magazines
- Scissors
- Paste
- White paper or cardboard
- A variety of scrap materials for collage

PROCEDURE

1. Find magazine pictures that contain areas of interesting textures such as hair, grass, cloth patterns, sky with clouds, and so on.
2. Cut out shapes from textured areas to create a picture. Mix up textures.
3. Paste textured shapes into place on a piece of white paper or cardboard.

SUGGESTIONS AND VARIATIONS Add other materials such as string, yarn, dry cereal, cardboard, feathers, buttons, beads, sand, fabric, aluminum foil, toothpicks, and so on. This will add actual texture to the collage.

Letter Designs

SUPPLIES

- Magazines
- Scissors
- Paste
- White or colorful construction paper

PROCEDURE

1. From magazines, cut out letters of all sizes, shapes, and colors.
2. Choose a white or colorful construction paper background and arrange letters until a pleasing landscape or human figure is formed.
3. Paste letters into place.

SUPPLIES

- Construction paper
- White paper
- Paste

PROCEDURE

1. Using various colors of construction paper, demonstrate making shapes and forms by tearing instead of cutting the paper. The jagged edges add texture and interest to any design or picture.
2. Choose a contrasting color construction paper or plain white paper for the background. Arrange torn paper shapes to create a design or picture.
3. Paste into place.

Borderline Designs

SUPPLIES

- Construction paper
- Scissors
- Paste
- White paper

PROCEDURE

1. Choose two pieces of contrasting construction paper, one piece half the size of the other. The design will be cut from the small piece of paper; the larger piece will serve as background paper.
2. Cut various shapes from the edges of the border of the smaller piece of paper. Make sure to cut them in one piece, vary their sizes, and save them as you go along.
3. Center what is left of the smaller piece of paper on the background paper and paste.
4. Outside the border of the smaller piece of paper, paste the saved shapes next to the place from which they were cut. The resulting design will look as if each shape was folded back from its original position.

PAPER MOSAICS

SUPPLIES

- Construction paper or magazine scraps
- Scissors
- Glue
- Tweezers
- Pencil or crayon
- Drawing paper

PROCEDURE

1. Explain that a mosaic is a design or picture composed of small pieces of colorful material. Point out that in ancient times, mosaics were made from small pieces of colored glass, stones, or ceramic tile embedded in an adhering agent.
2. Draw a design or picture on drawing or construction paper using a pencil or crayon.
3. Cut contrasting construction paper or magazine scraps into small pieces. Keep the pieces uniform in size and sorted by color.
4. Glue these pieces to the drawing paper, leaving a narrow space of background color in between each piece. Tweezers are a good tool to help pick up and place pieces.

SUGGESTIONS AND VARIATIONS
Design another mosaic with other materials such as seeds, grains, or confetti.

DRINKING-STRAW MOSAICS

SUPPLIES

- Drinking straws
- Cardboard
- Glue
- Scissors
- Pencil
- Construction paper

PROCEDURE

1. Using a pencil, draw a design or picture on cardboard.
2. Cut straws into uniform small lengths.
3. Apply a drop of glue to the cardboard and press the straw gently into place, perpendicular to cardboard. You may follow the outline or fill in solid areas with many straw pieces.
4. Try varying the lengths of straw pieces to create interesting textures.
5. Add color by cutting and gluing down pieces of construction paper to cardboard before gluing straw pieces in place.

SUPPLIES

- Construction paper
- Scissors
- Paste
- Stapler
- Clear tape
- Tempera, water, brush, sponge

PROCEDURE

1. Demonstrate and encourage experimentation with shaping two-dimensional paper into three-dimensional forms. Fascinating paper sculpture can be made by bending, curling, cutting, rolling, folding, pleating, fringing, perforating, slitting, twisting, and so on.
2. Make different shapes and forms using construction paper and scissors. Experiment with a wide range of paper sculpture techniques.
3. Create a creature by stapling or taping some of these paper shapes together. A simple rolled-paper cylinder can serve as the body of an animal or figure.
4. Add details by painting with a brush and tempera.

SUGGESTIONS AND VARIATIONS As a class project, create a whole zoo or farm using paper sculpted animals, people, and buildings.

SUPPLIES

- Colorful tissue papers
- Scissors
- White glue
- Water
- Heavy white paper or cardboard
- Wide brush
- Black crayon, ink, or felt-tip marker

PROCEDURE

1. Cut out interesting shapes from different-color tissue papers. If tissue paper is not available from school supplies, it can be purchased inexpensively in greeting card stores.
2. Using black crayon, ink, or felt-tip marker, make a bold design or picture on heavy white paper or cardboard.
3. Make a glue solution using one part white glue, and one part water.
4. Use a wide brush to cover the entire design or picture with glue solution.
5. Place tissue-paper shapes on glue-coated drawing and brush over each piece of tissue again with glue solution.
6. Cover the drawing with tissue paper and glue solution and allow it to dry overnight.
7. When the drawing is dry, accent areas by touching up with black crayon, ink, or felt-tip marker.

SUPPLIES

- Colorful tissue paper
- Scissors
- Waxed paper
- Newspapers
- Iron

PROCEDURE

1. Using scissors, cut interesting shapes from bright tissue papers.
2. Place newspaper on a flat surface and one sheet of waxed paper on top of newspaper.
3. Arrange tissue-paper shapes on waxed paper in an attractive design.
4. Place a second sheet of waxed paper on top of tissue shapes. Place another sheet of newspaper on top of waxed paper and press gently with a warm iron to form the transparency. The heat will help waxed papers stick together.

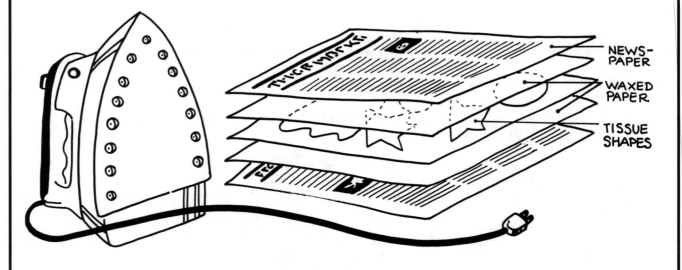

NEWS-PAPER

WAXED PAPER

TISSUE SHAPES

5. Trim the edges of the transparency and display in front of a window or light source.

SUGGESTIONS AND VARIATIONS
This activity may be used to reinforce principles of the color wheel. Colors blend when tissue papers overlap. When two primary colors overlap, they blend to form a secondary color. Try this technique again, this time embellishing the design by adding leaves, grass, weeds, and so on.

SUPPLIES

- Potato, carrot, or turnip
- Scraping tool
- Paring knife for teacher
- Tempera
- White drawing paper for printing
- Paper towels
- Water
- Spoon
- Jar lid or shallow container

PROCEDURE

1. Using a paring knife, precut vegetables in half for each child.
2. Distribute scraping tools, such as bobby pins, metal nail files, or orange sticks. Have children scrape a design into the smooth side of each vegetable. Because they are larger and easier to scrape, potatoes are recommended for younger children.
3. Fold a wet paper towel into a small pad. Place the pad in a jar lid or other shallow container. Carefully spoon small amounts of tempera on top of paper towel until saturated. This ink pad will distribute paint more evenly over the vegetable than would brushing the vegetable with paint.
4. Have each child press his or her vegetable half on the ink pad and then onto a sheet of drawing paper. Make a design by repeating these printed shapes.
5. Add variety to the pattern by using both halves of the vegetable and cutting and printing two different designs. Experiment with various patterns by alternating designs.

SUGGESTIONS AND VARIATIONS
Try printing in various colors using construction paper, tissue paper, brown wrapping paper, manila, or newsprint. These printed patterns will make beautiful wrapping paper, greeting cards, or book covers.

SUPPLIES

- Small frozen-juice can with top and bottom cut off, rolling pin, or cardboard tube
- String or yarn
- Glue
- Tempera
- Paintbrush
- White drawing paper for printing
- Scissors

PROCEDURE

1. Make a design on a tin can, rolling pin, or cardboard tube by gluing pieces of string or yarn over as much of the area as possible.
2. Paint the string or yarn with a brush and tempera.
3. Roll the can, rolling pin, or tube across the drawing paper while paint is still wet. You will create a beautiful design.

Gadget Printing

SUPPLIES

- Gadgets and objects such as bottle caps, jar lids, corks, pipe cleaners, sticks, twigs
- Tempera
- White drawing paper for printing
- Paper towels
- Water
- Jar lids or other shallow containers
- Spoon

PROCEDURE

1. Make ink pads with different colors of tempera. Follow instructions given in ''Vegetable Printing'' on page 61.
2. Choose a gadget or object and one-color ink pad and make a design by pressing gadget to ink pad and printing on paper.
3. Choose another gadget and a different-colored ink pad, press, and add this print to the design.
4. Repeat this procedure many times to create an interesting printed pattern.

SUPPLIES

- Cardboard
- Rubber cement
- Pencil
- Scissors
- Printing ink
- Brayer
- Glass, formica, cookie sheet, or other smooth surface for rolling ink
- White drawing paper for printing

PROCEDURE

1. Using scissors, cut realistic or abstract cardboard shapes to form a design or picture.
2. Make a cardboard printing plate by using another piece of cardboard as a background on which to fasten cardboard shapes in place with rubber cement.
3. Use a pencil to etch deep lines into the cardboard. The lines will remain white on the finished printed design, adding needed detail.
4. After making sure that cement is dry and cardboard shapes secure, squeeze printing ink onto smooth surface. Roll brayer through ink and then over the cardboard plate. Do this until all cardboard shapes are covered with ink.
5. Place a sheet of paper on top of the cardboard plate and rub gently. The ink design will be transferred from cardboard to paper.
6. Pull the paper print up gently. Allow to dry.

SUGGESTIONS AND VARIATIONS Don't throw away cardboard printing plates. Recycle them! Allow ink to dry or make a new cardboard design. Apply rubber cement to cardboard plate and gently press down a sheet of aluminum foil that is larger than the plate. Fold aluminum foil around cardboard edges and rubber cement to back of cardboard plate. When rubber cement dries, apply black tempera with a brush. Cover the entire design. When the paint dries, take a wad of fine steel wool and brush away areas of black paint so that highlights of foil show through. Use a coat of shellac or polymer to protect the finished work.

Glue Printing

SUPPLIES

- Glue, Elmers or Duco cement
- Cardboard
- Printing ink or tempera
- Brayer or brush
- Glass, formica, cookie sheet, or other smooth surface
- White drawing paper for printing

PROCEDURE

1. Place the cardboard on a flat surface.
2. Using glue directly from the bottle or tube, squeeze a design onto the cardboard. (When using Duco cement, the work area should be well ventilated.) Make sure the glue design is heavy and raised from the surface. Allow to dry.
3. Squeeze ink from tube onto a smooth surface. Coat brayer with ink by rolling over inked surface. Then roll brayer over cardboard. If ink is not available, paint the raised design with tempera and a brush.
4. Place a sheet of paper over inked or painted cardboard and glue design. Use hands to rub back of paper.
5. Pull the print gently up and allow to dry.

Leaf Printing

SUPPLIES

- Leaves of various shapes and sizes
- Wide brush
- Newspapers
- Tempera
- White drawing paper for printing and/or construction paper

PROCEDURE

1. Distribute newspapers and cover work area.
2. Tear other newspapers into pieces that are larger than leaves. Place one leaf on one small piece of newspaper. Thin, flat leaves will yield the best results.
3. Brush over one side of leaf completely with tempera. The back side of the leaf will give a more linear quality to the finished print.
4. Place the leaf, painted side down, on white drawing paper or construction paper. Then cover the leaf with another piece of newspaper.
5. Rub with hands and remove top newspaper and leaf to discover a leaf print on paper.
6. Repeat the procedure using other leaves and different colors. Allow to dry.

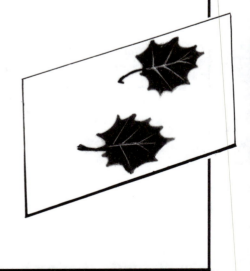

Bowls, vases, and figures can be molded from clay, using any of the following methods. The basic supplies are the same in all three methods. If commercial clay is not available, use the recipes for homemade clay on page 67.

BASIC SUPPLIES

- Reusable or self-hardening clay
- Tempera, brush, water, sponge
- Shellac and shellac brush

METHOD I: PINCH POT

PROCEDURE

1. Use a small piece of clay that fits comfortably in hands and mold it into a ball.
2. Press one or both thumbs into the center of ball. Press thumb(s) around inside while holding the clay ball firmly on the outside with other fingers.
3. Make sure sides are even by turning clay bowl while working.
4. Finish hardened pieces by painting with tempera.
5. Allow to dry and coat with shellac.

METHOD II: SLAB

ADDITIONAL SUPPLIES

- Rolling pin or jar
- Table knife
- Water

PROCEDURE

1. Roll out clay using a rolling pin or jar turned on its side. Clay should be about 1/2 inch (12 mm) thick.
2. Using a table knife, cut pieces from clay slab, which will serve as sides and base of bowl or vase.
3. Join cut pieces by smoothing additional clay over the inside and outside joints as you assemble the bowl or vase. If necessary, dip fingers in water to help smooth clay over joints.
4. Decorate hardened clay with a brush and tempera.
5. Allow to dry and coat with shellac.

METHOD III: COIL

PROCEDURE
1. Mold a ball of clay into a long, skinny roll by rolling between the palms of hands or on a flat surface. The finished roll should be about 1/4 inch (6 mm) in diameter and as long as possible.
2. Make the base of the bowl by coiling the clay roll on a flat surface. Once the base is big enough, continue to coil, piling the roll in a continuous, circular motion, to make sides of bowl.
3. When the sides of the bowl are high enough, use fingers to smooth clay on the inside and outside of the bowl until some or all of the coils are no longer visible. Make sure coils are securely joined, leaving some coils visible for decorative purposes only.
4. To flatten the bottom of the bowl, hold gently with both hands and tap on tabletop.
5. Paint and shellac the hardened clay.

MODELING FIGURES OR ANIMALS

PROCEDURE
1. Use one ball of clay for entire finished figure or animal. Pull *out* clay from the ball to make body parts such as heads, arms, legs, and ears. This method is preferable to attaching limbs with additional clay pieces, which may fall off.
2. For more detailed action figures, make a wire form. Twist and bend the wire to indicate body movements and model clay over the wire structure.
3. Paint and shellac hardened clay.

HARDENING CLAY

SUPPLIES

- Flour
- Salt
- Cold water
- Spoon for stirring
- Food coloring (optional)
- Containers or bowls

PROCEDURE

1. Mix equal parts of flour and salt in large bowl.
2. Gradually add cold water, stirring constantly until a good modeling consistency is attained. If color is desired, add food coloring to water before adding water to flour and salt.
3. Clay can be painted and shellacked after drying thoroughly for at least forty-eight hours.

REUSABLE CLAY

SUPPLIES

- Water
- Salad oil
- Food coloring (optional)
- Flour
- Salt
- Covered jar
- Measuring cups and spoons
- Bowl

PROCEDURE

1. In a jar, add 2 tablespoons (30 ml) salad oil to 1 cup (250 ml) water. Add food coloring if desired. Cover and shake vigorously to mix.
2. In a bowl, mix 1 1/2 cups (375 ml) salt and 4 cups (1,000 ml) flour.
3. Gradually add water and oil mixture to dry ingredients. Work with hands and mix thoroughly until mixture becomes similar to consistency of bread dough. It may be necessary to add water to make mixture more pliable.
4. Store mixture in tightly sealed jars immediately after use.

SUPPLIES

- Newspapers
- String
- Paper towels
- Scissors
- Wheat paste or flour and water
- Bowls
- Tempera, brushes, water, sponge
- Shellac and shellac brush

PROCEDURE

1. There are two methods for making papier-mâché figures and creatures. Either crumple up newspaper and hold it together with string or use rolls and wads of newspaper to form the basis of figures and creatures.
2. In either case, wrap string around the pieces of newspaper several times to hold them together.
3. Using scissors, cut many newspaper strips, about 1 inch (2 1/2 cm) wide.
4. Prepare wheat paste or mix flour and water in a bowl to form a thin paste.
5. Dip a newspaper strip into the paste mixture. Run the strip between two fingers to remove excess paste. Cover the newspaper figure with strips. Apply two or three layers of pasted strips to the entire figure.
6. Cut similar strips from paper towels, dip in paste, and use as the last layer so that the newsprint will not show through.
7. Add details to the figure. Use hands to cover a full sheet of newspaper with paste. Place a second sheet of newspaper on top and reapply paste. Repeat this procedure until you attain a thickness of five layers of paste and paper.
8. Using scissors, cut from the layered papers any shapes needed for details. When partially dry, these layered papers may be folded, curled, or bent. When entirely dry, they will hold their shape.
9. Use paste mixture to attach detail pieces to the main figure.
10. Allow to dry, then paint and shellac.

SUPPLIES

- Newspapers
- Scissors and/or knife (for teacher)
- Wheat paste or flour and water
- Bowls
- Balloons
- Sandpaper
- Tempera, water, brushes, sponge
- Shellac or polymer, brush
- Paper towels
- Scrap materials such as yarn, cotton swabs, buttons
- Glue

PROCEDURE

1. Cut newspaper into strips 1/2 inch (12 mm) wide.
2. Prepare wheat paste or mix flour and water in a bowl to form a thin paste.
3. Inflate a balloon to desired size and tie a knot.
4. Dip paper strips into paste mixture, running strips between fingers to remove excess paste.
5. Place paste-coated strips onto balloon until the entire balloon is covered.
6. Paste at least six layers of strips, the last of which should be made from paper towels instead of newspaper to prevent newsprint from showing through. Apply strips in different directions to strengthen finished mask, making sure wrinkles and bubbles are smoothed away with fingers.
7. Allow papier-mâché to dry.
8. After papier-mâché is completely dry, let the air out of the balloon. Cut papier-mâché sphere in half with a knife or scissors. These halves become the bases for two masks.
9. Use sandpaper to soften sharp edges inside and out before decorating.
10. Cut openings for eyes and add facial features with either more papier-mâché or by gluing on other materials such as yarn, cotton swabs, or buttons.
11. Paint finished mask with tempera.
12. Allow to dry and brush on protective coat of shellac or polymer.

SUPPLIES

- Paper bags
- Crayons or felt-tip markers
- Construction paper
- Glue
- Scissors
- String
- Dowel or stick
- Tissue paper, paper napkins or paper towels

PROCEDURE

1. Turn a paper bag upside down. The bottom will be the puppet's head.
2. Using about one-fourth of the bag's surface as a face, add facial features with crayons, felt-tip markers, or pieces of construction paper and glue. Use your imagination to create hair, eyebrows, lashes, and so on, from cut paper, cotton swabs, yarn, or string.
3. Stuff this section of the bag with tissue, napkins, or paper towels, being careful not to tear the bag.
4. Insert a long stick or dowel gently inside the paper bag, resting it in the tissue, napkins, or toweling.
5. Tie off with string in the spot where neck should be.
6. Add arms or other features by cutting and pasting simple colored construction-paper shapes to lower section of bag.
7. Make one puppet or a whole family. Have fun creating stories or plays to go along with puppets.

SUPPLIES

- Construction paper
- Scissors
- Paste
- Pencils or crayons

PROCEDURE

1. Using a pencil or crayon, draw a head and neck of a figure or animal on a piece of construction paper. The head should be slightly bigger than the tip of a finger.
2. Cut out head, neck, and extra strips on both sides of the neck.
3. Draw additional features with crayons.
4. Form a band that fits around the fingertip by pasting together ends of strips.
5. Place fingertip through pasted loop and wiggle finger to animate puppet.

Dancing Finger Puppets

SUPPLIES

- Construction paper
- Scissors
- Paste
- Pencils or crayons

PROCEDURE

1. With a pencil or crayons, draw the head and torso of a figure or animal on construction paper.
2. Cut out head, torso, and strips, which extend from hip level of figure or animal.
3. Add facial details and decorations with crayon.
4. Paste together the ends of strips to form a loop large enough to fit around index and middle fingers.
5. Place fingers through the loop to form legs. Wiggle fingers to make puppet dance.

SUPPLIES

- Empty wooden spools, small, medium, and large
- Heavy cord
- Tempera, brushes, water, sponge
- Scissors
- Strong button or nylon thread
- Tongue depressors or heavy cardboard strips

PROCEDURE

1. Weeks before beginning activity, collect empty wooden spools of different sizes.
2. Cut four long lengths of heavy cord and tie together by knotting at one end.
3. Thread all four ends through the hole of a medium-sized spool. The securing knot should be large enough to stay outside the hole.
4. Separate cords, and thread one through the holes of two small spools to form an arm. Thread two center cords through one large spool to form torso and the remaining cord through two more small spools to form the other arm. Separate cords from torso and thread each one through two small spools to form legs. Tie large knots at the end of each group of spools to keep them in place.
5. Add facial and clothing features with tempera and allow to dry.
6. Tie several strong lengths of button or nylon thread to marionette parts—one to head knot, one to each of two arm knots, and one to each of two knee joints (space between two spools that make up each leg).
7. Attach marionette strings to tongue depressors or heavy cardboard strips as shown below:

To attach thread, punch a hole with scissors and tie securely with a knot. Tie or glue string to marionette. A single strip controls the marionette's legs, and a cross of strips controls the head and arms.

SUPPLIES

- Quick-drying glue, such as Duco cement
- Flat toothpicks
- Wax paper
- Spring-type clothespins
- Tissue paper or construction paper
- Tempera, brush, water, sponge
- Scissors

PROCEDURE

1. Using wax paper as protective covering, glue toothpicks together to create realistic and abstract forms and designs.
2. To make toothpick structures, glue three toothpicks together to form a two-dimensional triangle. Keep work flat and make additional triangles.
3. Glue triangles together to form units.

4. Make many units and allow to dry.
5. Assemble units to make a structure and glue units in place as work progresses. Use spring-type clothespins to hold toothpick units together while glue dries.
6. Make imaginary forms or realistic structures. To add color and interest, paint with tempera. Or cut and glue tissue paper or construction paper to structure.

SUPPLIES

- Nylon thread
- Supports, such as hanger wire or wooden dowels
- Wire cutter or heavy scissors (for teacher)
- Glue
- Various materials for suspension, such as heavy paper, wire, cardboard, straws, metal, foil
- Tempera, brushes, water, sponge
- Crayons

PROCEDURE

1. Choose a theme for your mobile. Objects to be suspended should have a relationship to one another.
2. Decide on the number of objects to be suspended and the materials from which they will be made, such as wire, heavy paper, cardboard, or a combination of materials.
3. Younger children may make only one object to suspend from a mobile; older children may make several objects. Decorate the objects with tempera or crayons and attach a nylon thread to each.
4. Cut a support piece from wire with a wire cutter or heavy scissors, or use a wooden dowel.
5. Suspend an object from each end of support piece and tie in place. Make sure the objects are placed far enough apart so they don't touch when hanging. To reinforce the point of attachment, add a drop of glue. Experiment with different lengths of thread to create interest.
6. Tie another thread to the dowel or wire. Hold the mobile by this thread. Find a point of balance by sliding the thread back and forth. When balance point is found, hold thread in place with a drop of glue.

SUGGESTIONS AND VARIATIONS Tie a long piece of
string or wire across the back of classroom so that children can suspend their mobiles while working.

SUPPLIES

- Heavy colorful string
- Waxed paper
- White glue
- Pencil
- Drawing paper
- Tape
- Containers such as aluminum pie plates or jar lids
- Colorful tissue paper or cellophane

PROCEDURE

1. With a pencil, draw a figure, object, or design on drawing paper.
2. Place a piece of waxed paper over the drawing paper and secure corners with tape.
3. Dip string in container of white glue, making sure the string is thoroughly coated.
4. Place the string over the line design.
5. Allow to dry.
6. Add color to the string design with colorful tissue paper or cellophane. Choose shapes to be colored and lay stiff string design on top of tissue or cellophane. Trace an opening onto paper, leaving an extra margin all around to allow room for gluing to string.
7. Apply glue to string and paste paper shape in place on the back side of design.

SUGGESTIONS AND VARIATIONS These sculptures make beautiful displays by themselves, in groups, or dangling from mobiles.

SUPPLIES

- Salt
- Flour
- Powdered alum
- Bowl
- Toothpicks
- Food coloring or dry tempera
- Ball of clay
- String
- Rolling pin or jar
- Shellac and brush
- Blunt table knife (butter knife)

PROCEDURE

1. Mix 1 cup (250 ml) salt, 1 cup (250 ml) flour, and 1 tablespoon (15 ml) powdered alum (available in art supply stores) in a bowl. Mix with hands until it reaches the consistency of putty. If color is desired, add food coloring or dry tempera.
2. Shape a ball of mixture into a round bead by rolling between palms of hands.
3. Make flat beads of different sizes and shapes by rolling out mixture with a rolling pin or side of jar. Cut out flat shapes with a blunt table knife.
4. Use a toothpick to make a hole in each bead. Leave the toothpick in place and stick it into ball of clay to dry.
 To prevent sticking, turn toothpicks in beads a few times while drying.
5. When dry, apply shellac, redry, and string.

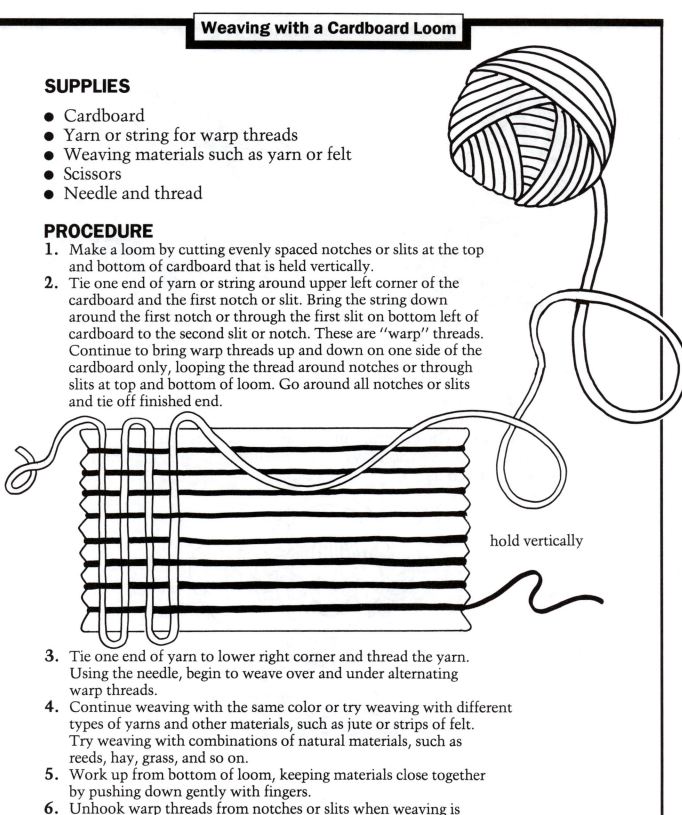

SUPPLIES

- Cardboard
- Yarn or string for warp threads
- Weaving materials such as yarn or felt
- Scissors
- Needle and thread

PROCEDURE

1. Make a loom by cutting evenly spaced notches or slits at the top and bottom of cardboard that is held vertically.

2. Tie one end of yarn or string around upper left corner of the cardboard and the first notch or slit. Bring the string down around the first notch or through the first slit on bottom left of cardboard to the second slit or notch. These are "warp" threads. Continue to bring warp threads up and down on one side of the cardboard only, looping the thread around notches or through slits at top and bottom of loom. Go around all notches or slits and tie off finished end.

hold vertically

3. Tie one end of yarn to lower right corner and thread the yarn. Using the needle, begin to weave over and under alternating warp threads.

4. Continue weaving with the same color or try weaving with different types of yarns and other materials, such as jute or strips of felt. Try weaving with combinations of natural materials, such as reeds, hay, grass, and so on.

5. Work up from bottom of loom, keeping materials close together by pushing down gently with fingers.

6. Unhook warp threads from notches or slits when weaving is complete.

Children love to create whimsical interpretations of holiday symbols, such as ghosts, pumpkins, black cats, turkeys, Pilgrims, Santa Claus, valentines, bunnies, and Easter eggs. The activities in this section celebrate the excitement of the holidays with a creative and imaginative use of materials.

SUPPLIES

- Paper plates
- Scissors
- Crayons
- Tempera, brushes, water, sponge
- String
- Various materials for decorating, such as yarn, construction paper, buttons, beads, and so on
- Pencil
- Glue

PROCEDURE

1. With pencil or crayon, mark on paper plates the placement of eyes, nose, and mouth.
2. Cut holes in the plate where indicated.
3. Decorate the masks with crayons, tempera, construction paper, and other odds and ends. Fringed and curled construction paper makes hair for lashes, brows, and heads. Use yarn or cotton swabs for hair, mustaches, and beards.
4. Punch a hole on each side of the plate and tie with a length of string. Make sure strings are long enough to go around child's head.

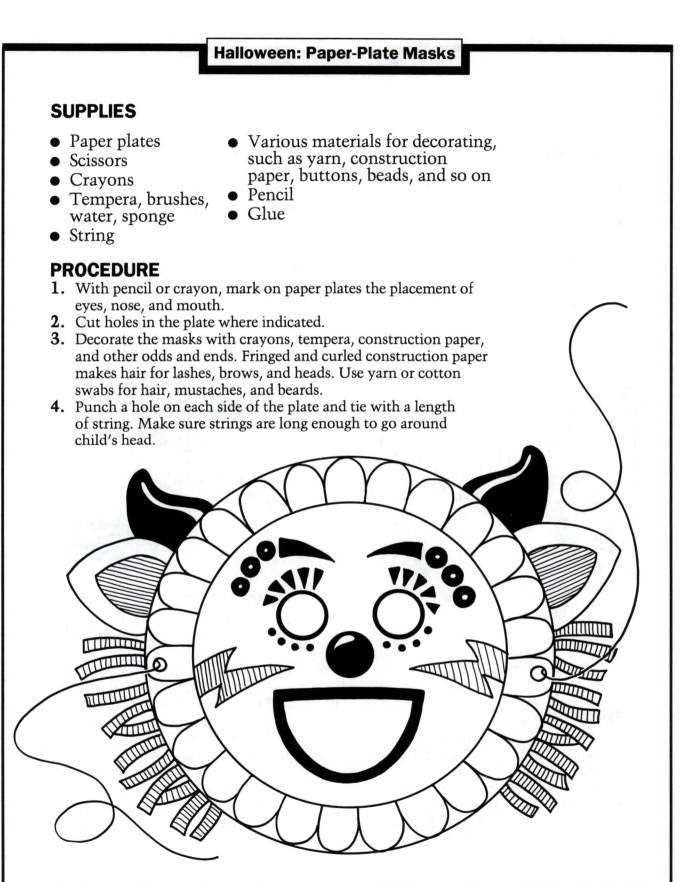

PAPER-BAG MASKS

SUPPLIES

- Paper bags large enough to fit over child's head
- Scissors
- Crayons
- Tempera, brushes, water, sponge
- Glue
- Various materials for decorating, such as yarn, construction paper
- Pencils

PROCEDURE

1. With pencil or crayon, mark on paper bags the placement of eyes, nose, and mouth.
2. Cut holes in the bag where indicated.
3. Decorate the masks with crayons, tempera, yarn for hair, paper flaps for ears, paper teeth for mouth, and so on.

SILHOUETTES

SUPPLIES

- Transparent watercolors
- Paintbrushes
- Black tempera
- Sponge
- Water
- Drawing paper
- Paper towels

PROCEDURE

1. Wet drawing paper with a damp sponge. Blot up excess water with paper towel.
2. Using transparent watercolors and a paint-saturated brush, touch the brush to wet drawing paper to make wet-on-wet designs. This will serve as background for silhouettes.
3. Allow the background to dry and paint a Halloween scene or figures in black tempera. Haunted houses, ghosts, skeletons, and witches make wonderful silhouettes on a colorful background.

SUPPLIES

- Giant paper bags
- Scissors
- Tempera, brushes, water, sponge
- Crayons
- Glue
- Pencils
- Various materials for decorating, such as buttons, yarn, cotton, construction paper

PROCEDURE

1. Using pencil or crayon, mark holes on paper bags for arms, eyes, nose, and mouth.
2. Cut openings.
3. Decorate with crayon, tempera, and/or other odds and ends.

SUPPLIES

- Pine cones (available at craft supply stores)
- Pipe cleaners
- Brown construction paper
- Crayons
- Tempera, brushes, water, sponge
- Glue
- Scissors
- Pencils

PROCEDURE

1. The pine cone forms the body of the turkey. On construction paper, use crayon and/or pencil to draw a tail and head for the turkey.
2. Cut out head and tail and decorate with crayons or tempera.
3. Glue the tail to the wide portion of the pine cone and the head to the narrow end.
4. Create legs for turkey by wrapping pipe cleaners around the middle of pine cone. Hide pipe cleaners among the petals of the cone. Extend pipe cleaners down and bend the ends to make feet.

SUPPLIES

- Aluminum foil
- Newspaper
- Glue or clear tape

PROCEDURE

1. Unroll a foot (30 cm) of aluminum foil.
2. Pleat the foil to form a tail and join with glue or clear tape.
3. Unroll another foot (30 cm) of aluminum foil.
4. Crumple newspaper to make a ball. Place the newspaper ball in the center of the foil sheet, dull side up.
5. Mold the foil around newspaper to make head and body of a turkey.
6. Glue or tape the pleated foil in place.

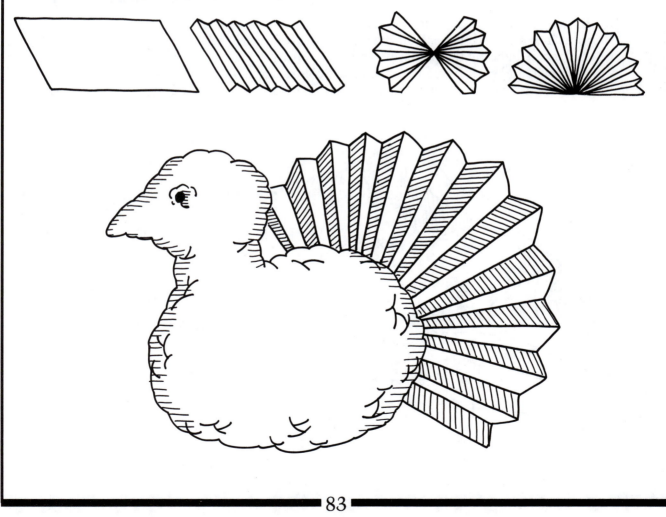

SUPPLIES

- Soft cardboard or oaktag
- Aluminum foil
- Tape or stapler
- Tissue paper in various colors
- Glue
- Scissors

PROCEDURES

1. Roll a large sheet of soft cardboard or oaktag into a cone shape. Tape and/or staple to secure. With scissors, trim the edges so that the cone has a slanted mouth.
2. Cut several long sheets of aluminum foil and wind around cardboard cone.
 Mold the foil to a point and leave edges extending beyond a large rim.
3. Remove the cardboard cone and gently shape the foil point into a curled shape. Roll the ends of the foil into a thick edge, bending the point and edges gracefully.
4. Wad, roll, and stuff tissue paper to create colorful and attractive fruits and vegetables. Glue these in place inside cornucopia.

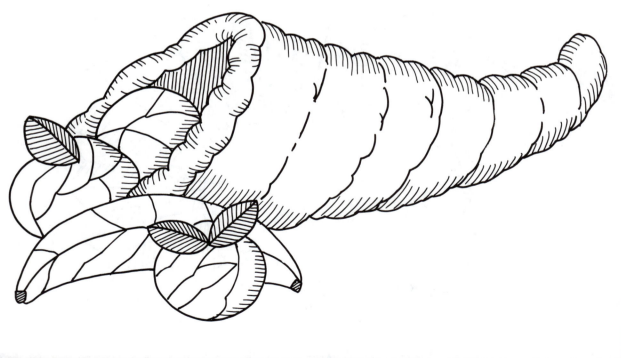

SUPPLIES

- Construction paper
- Styrofoam balls (available at craft supply stores)
- Scissors
- White glue
- Crayons
- Pencils
- Felt
- Yarn

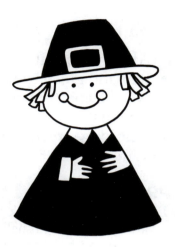

PROCEDURE

1. Fold a piece of construction paper in half and draw a half circle on the fold with pencil or crayon. Cut out and unfold.

2. Cut a slit to the center of the circle to create a cone. Bend, roll, overlap ends, and glue in place to form the bodies of Pilgrims and Native Americans. Trim the edges with scissors if necessary.

3. To make a head, carefully pierce a small hole in the Styrofoam ball with point of pencil. Apply a small amount of glue to the tip of the paper cone and insert it into hole of Styrofoam ball.

4. Draw and cut arms from construction paper and glue them to the cone.

5. To dress a Native American, draw and cut from construction paper or felt scraps feathers and facial features. Glue these to the head and body. Use cut and fringed construction paper to make clothing; use yarn to make hair.

6. To dress a Pilgrim, cut and draw from construction paper details for face, hair, and clothing. Glue these in place. To make the Pilgrim's hat, cut, roll, and glue a small cone shape from construction paper. Cut off the point and glue on a construction-paper buckle.

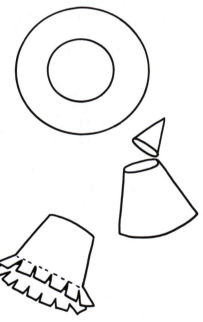

Cut from construction paper a circle larger than opening at the bottom of the cone. Place the opening of the cone on the large circle and trace its circumference. Draw a slightly larger circle around the traced circumference. Cut out this circle to make the hat's brim.

Cut fringes into the edge of the cone. Bend. Ease the hat brim over the top of cone and paste or tape fringes onto the underside of the brim.

Christmas:
Toothpick and Starburst Ornaments

SUPPLIES

- Aluminum foil
- Red and green toothpicks
- Needle and thread
- Scissors
- Drinking straws
- Wire

PROCEDURE

1. To make a toothpick ornament, mold a piece of aluminum foil into a small, tight ball.
2. Insert toothpicks into the foil ball to form a star design.
3. Use a needle and thread to make a loop from which to suspend the ornament.
4. To make a starburst ornament, gather ten to twenty drinking straws and bind them tightly at the center with a wire. Make sure the wire is long enough to be used as a hook.

5. Carefully open the straws into a starburst. Cut the straw tips into points.

SUPPLIES

- Drinking straws
- Box
- Needle and thread
- Construction paper
- Scissors
- Glitter
- Glue

PROCEDURE

1. Cut many drinking straws into lengths of 1 inch (2 1/2 cm) or more. Cut over a box so that straws do not scatter over the floor.
2. Cut small Christmas shapes such as stars, trees, bells, and so on out of construction paper. Decorate some or all with glue and glitter.
3. Using a needle and thread, string the straw pieces and paper shapes to form a decorative garland.

SUPPLIES

- Balloons
- Paste made of flour and water
- Bowls or aluminum pie plates
- Heavy string or yarn
- Oaktag
- Waxed paper
- Stapler or masking tape
- Scissors
- Glitter
- Glue
- Tissue paper or cellophane
- Tempera, brushes, water, sponge

PROCEDURE

1. To make a starched-string ball, blow up a small round balloon and knot it.
2. In small bowls or disposable aluminum pie plates, mix flour and water into a thick paste.
3. Dip lengths of yarn or string into the paste, pulling the string between your fingers to remove excess paste.
4. Wrap paste-laden string around a balloon to create loop designs. Do not cover the entire balloon with string.
5. Allow paste to dry thoroughly.
6. Pop and remove the balloon.
7. Decorate the string ball with tempera, glitter, tissue paper or cellophane.
8. To suspend the ball, tie a length of string to it.
9. To make a starched-string Christmas tree, form a base by making a cone shape with oaktag. Bend and roll the oaktag to form a cone and secure it with staples or masking tape.
10. Cover the cone with waxed paper and secure it with tape.
11. Dip lengths of string or yarn in paste mixture, remove excess paste and wrap the string around the cone in loop patterns.
12. Allow a full day for paste to dry.
13. Decorate with glitter, tempera, tissue or cellophane, or a combination of these materials.
14. Allow to dry.
15. Remove the paper cone and display it in the classroom or use as table decoration for Christmas parties.

SUPPLIES

- Oaktag and cardboard
- Scissors
- Stapler or masking tape
- White glue
- Raw macaroni in various sizes and shapes
- Tempera or metallic spray paint
- Paper cups or bowls
- Ribbon

PROCEDURE

1. To make a tree, bend and roll oaktag to make a cone. Staple or secure it with masking tape. Trim the edges if necessary.
2. Sort different sizes and shapes of macaroni into paper cups or bowls.
3. Spread white glue over small area of cone and fasten pieces of macaroni by pressing and holding in place. Repeat this procedure until the entire tree is covered with pasta.
4. Allow the glue to dry and paint with either tempera or with gold, silver, or bronze spray paint, if available.
5. Adorn the top of the tree by gluing a bow of plain or velvet ribbon.
6. To make a macaroni wreath, use a cardboard circle as a base. Cut away the center of the circle to make a wreath shape. Staple a looped ribbon to back of the wreath. Apply glue to the wreath and gently press macaroni to glue.
7. Allow glue to dry and paint the wreath with tempera or metallic spray paint, if available.
8. For added color and decoration, tie a bright red bow to the finished wreath.

SUPPLIES

- Aluminum foil
- Construction paper
- Stiff paper or oaktag
- Scissors
- Stapler
- Glue
- Ribbon
- Styrofoam balls
- Felt scraps

PROCEDURE

1. To make a cone angel, construct two paper cones from either stiff paper or oaktag. The first cone should be 9 inches (23 cm) tall and the second should be 7 inches (18 cm) tall and slightly wider than the first. Bend and roll paper into cone shapes and secure with glue or staples. Cover with aluminum foil, if desired.

2. Apply a small amount of glue to top of the larger cone and place the smaller cone on top.

3. Cut arms and wings from construction paper and cover with foil on both sides, if desired. Fasten the arms and wings to the cone with glue.

4. Punch a hole in Styrofoam ball with scissors. Cover the point of the smaller cone with glue and insert the point into the hole in the Styrofoam ball.

6. Cut a length of ribbon and fringe it with scissors to create hair and lashes. Glue in place.

7. Make a halo by crushing aluminum foil and forming a ring. Hold in place with glue.

8. Create any other facial or clothing features using construction paper or felt scraps. Hold in place with glue.

SUPPLIES

- Cardboard tubes
- Aluminum foil
- Scissors
- Small bowl or cup
- Straight pins
- Candles
- Tissue paper, yellow and/or orange
- Glue
- Construction paper
- Clear tape

PROCEDURE

1. Cut nine cardboard tubes (from toilet tissue or paper towels). Each tube should be 1 inch (2 1/2 cm) taller than the previous one, starting with a 4-inch (10-cm) tube and ending with a 12-inch (30-cm) tube.
2. Cover each tube with aluminum foil, pushing excess foil into the ends.
3. Turn a very small bowl or cup without handles upside down to use as a mold. Mold four small sheets of aluminum over the bowl. Remove the aluminum from the mold. Gently roll and crimp foil to make decorative edges. Repeat procedure to make nine foil bowls.
4. To make a Star of David, cut foil 4 inches (10 cm) wide and 12 inches (30 cm) long. Crush and connect the ends to form a loop. Make the loop into a triangle. Repeat to make a second foil triangle. Use both triangles to make the star. Use additional foil to connect the triangles. Attach the foil stars to the foil tubes with pins.
5. Arrange the tubes in a semicircle and top each with a foil cup. Add candles to complete menorah.
6. Candles and flames can be made with construction paper, glue, and tissue paper. Make a candle by forming a tube out of construction paper and securing it with glue. Stuff one end of tube with yellow and/or orange tissue paper. Cut or tear edges to represent flames. Secure in place with glue. Fasten the other end of the paper tube to the inside of the foil cup with glue or clear tape.

Puzzle Cards

SUPPLIES

- Heavy construction paper or cardboard
- Scissors
- Crayons
- Tempera, brushes, water, sponge
- Envelope

PROCEDURE

1. Cut a heart shape from heavy construction paper or cardboard.
2. Write a message on the heart with crayons and decorate it with construction paper and/or tempera.
3. After glue and/or paint dries, cut the heart into jigsawlike pieces and put the pieces in an envelope.
4. Recipients of your valentines will have to assemble the pieces to read the messages.

Folded Cards

SUPPLIES

- Construction paper and/or drawing paper
- Scissors
- Glue

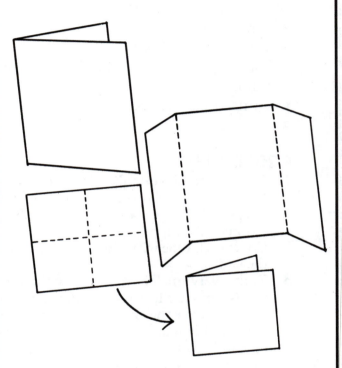

PROCEDURE

1. Fold construction paper or drawing paper using one of these methods.
2. Cut heart designs from construction paper.
3. Glue the designs to the cards.

Valentine's Day: Dancing Hearts

SUPPLIES

- Construction paper, red, pink, white
- Scissors
- Stapler or glue
- String

PROCEDURE

1. Cut a small and large heart out of construction paper. Glue the smaller heart at the top of the larger one.
2. Create arms and legs from paper strips cut from construction paper. Place the strips at right angles with the ends overlapping.

 Fold white strip over red, then red over white. Continue process until the desired length is reached. Fasten the ends with glue or staples.
3. Staple or glue arms and legs to the larger heart.
4. Cut small heart shapes from construction paper to make hands and feet. Glue to arms and legs.
5. Attach string to the top of the smaller heart. Jiggle string to make the heart dance.

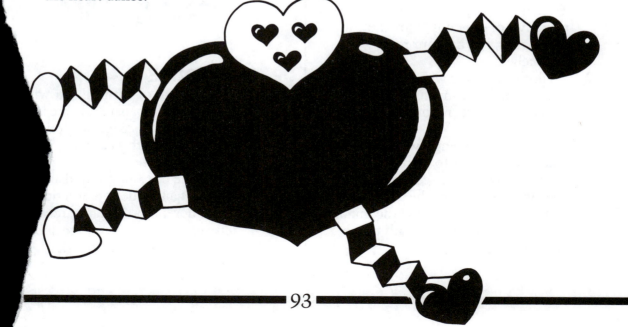

Egg-Carton Bunnies

SUPPLIES

- Egg carton
- Scissors
- Glue
- Crayons
- Construction paper

PROCEDURE

1. To make an egg-carton bunny, cut two rows of egg cups from one end of a carton, leaving four rows untouched.
2. To decorate, draw with crayons and cut out, or cut from construction paper, eyes, nose, mouth, whiskers, and ears.
3. Hold the carton lengthwise and use glue to fasten ears to the top cup sections, eyes to the second cup sections, whiskers to the third cup sections (place the nose in the middle of the whiskers), and mouth to the bottom sections.

Salt-Box Bunnies

SUPPLIES

- Salt or oatmeal box
- Construction paper
- Scissors
- Glue
- Crayons or markers

PROCEDURE

1. Cover a salt or oatmeal box wi[th] construction paper and glue i[t]
2. Review various paper-sculptu[re] techniques such as curling, [] and perforating.
3. Hold the box upright to dec[orate.] Cut out and glue constructio[n] eyes, nose, mouth, ears, and [whiskers.]
4. Use crayons or markers to add [details] such as a collar and bow tie.

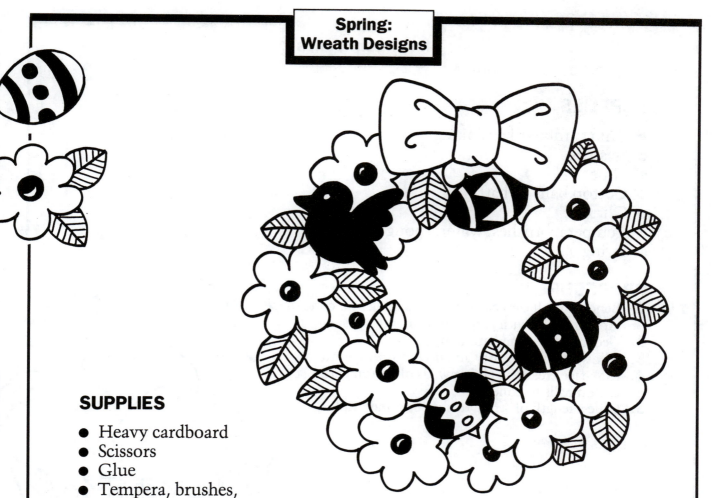

SUPPLIES

- Heavy cardboard
- Scissors
- Glue
- Tempera, brushes,
 water, sponge
- Crayons
- Ribbon or yarn
- Various materials for decorating,
 such as scraps of wallpaper,
 fabric, or construction paper
- Stapler

PROCEDURE

1. Cut a large circle from heavy cardboard. Cut away the center of
 circle to form a wreath shape. Before decorating, staple a loop of
 ribbon or yarn to the back of the wreath.
2. Cut out the cardboard shapes of flowers, leaves, birds, Easter
 eggs, and other seasonal objects.
3. Decorate the shapes with crayons, tempera, scraps of
 construction paper, wallpaper, or fabric. Overlap and fasten the
 shapes to the wreath with glue.
4. To the top of the wreath, add a bow made from ribbon or yarn.

SUPPLIES

- Thin cardboard or oaktag
- Scissors
- Glue
- Cotton balls or batting
- Glitter
- Tempera, brushes, water, sponge
- String

PROCEDURE

1. Bend and roll thin cardboard or oaktag into cone shape. Hold in place with glue and trim with scissors.
2. Decorate the cone with tempera.
3. Allow the paint to dry and decorate with glitter.
4. Make ice cream by gluing wads of cotton batting or cotton balls to cone.
5. Glue a length of string to the cone and display.